THE
COMIC BOOK
ARTIST'S
WORKBOOK

•

PERSPECTIVE

THE
COMIC BOOK
ARTIST'S
WORKBOOK

●

PERSPECTIVE

DAN COONEY

B.E.S.

PUBLISHING

CONTENTS

A QUARTO BOOK

First edition published in 2019 by
B.E.S. Publishing Co.

Copyright © 2019
Quarto Publishing plc
an imprint of The Quarto Group

All inquiries should be addressed to:
B.E.S. Publishing Co.
250 Wireless Boulevard
Hauppauge, New York 11788
www.bes-publishing.com

ISBN: 978-1-4380-1246-9
Library of Congress Control No.:
2018909847

QUAR.GNGP/306599

Conceived, edited, and designed by
Quarto Publishing plc
an imprint of The Quarto Group
6 Blundell Street
London N7 9BH
www.quartoknows.com

Senior editor: Kate Burkett
Design: Nick Clark (fogdog.co.uk)
Editorial assistant: Cassie Lawrence
Art director: Jess Hibbert
Publisher: Samantha Warrington

Printed in China

9 8 7 6 5 4 3 2 1

INTRODUCTION

8

1

ONE-POINT PERSPECTIVE
26

TWO-POINT PERSPECTIVE

THREE-POINT PERSPECTIVE

COMIC BOOK CRASH COURSE AND WORKBOOK

MEET DAN

My earliest memory of applying perspective to my drawings happened during an art lesson in middle school. Our art teacher briefly drew an example on the board and proceeded to hand out instructions of how to draw a house in two-point perspective. I really struggled with this exercise and could not master the principles of two-point perspective to make the house look three-dimensional.

Up until now, my drawings were only limited by my imagination. Now I was met with a new road block—in order to be able to draw scenes that looked to be in proper proportion, I needed to understand perspective and learn how to apply it on paper.

Frustrated with the poor grade I received on my perspective assignment, I left the classroom and began walking down the hallway. As I looked at the angles receding away from me, I noticed an object beyond the doors from which they converged to, and, like flicking on a light switch, I suddenly understood how to draw objects in perspective on paper.

I realized I could use what I saw in real life to help with my drawings. Fueled by this sudden understanding of the principles of perspective, I was inspired to draw scenes in one-point, two-point, and eventually three-point perspective.

I still struggled getting structures, objects, and even people to look entirely accurate, but, with time and practice, my drawings started to look convincing—they were composed with depth and made all the more dynamic because of perspective.

The aim of this book is to inspire artists to produce dynamic and convincing buildings, figures, and scenes in perspective for comic books and graphic novels. *The Comic Book Artist's Workbook: Perspective* familiarizes the artist with the key terms and principles before moving into dedicated chapters on each type of perspective—one-, two-, and three-point—and finishes with a unique insight into the creative process.

Treat this book as one of the many tools in your resources for improving your perspective drawing. Remember, practice makes perfect, and there is plenty of space to do just that on the gridded pages that sit alongside each exercise and in the workbook at the back of the book.

DANIEL COONEY

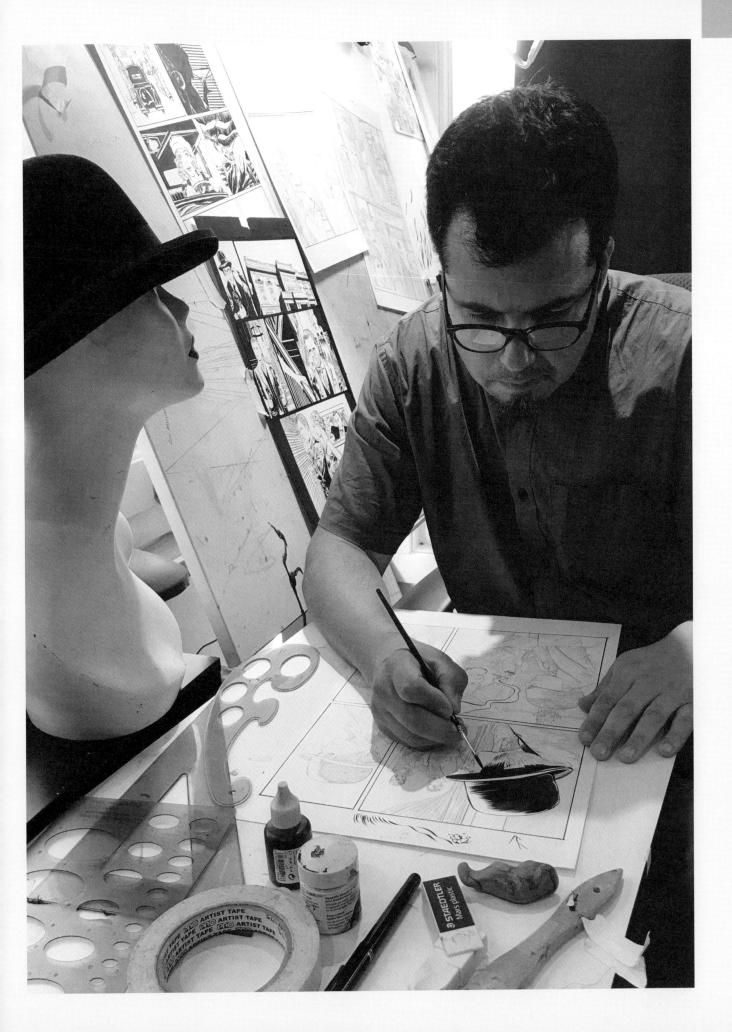

INTRODUCTION

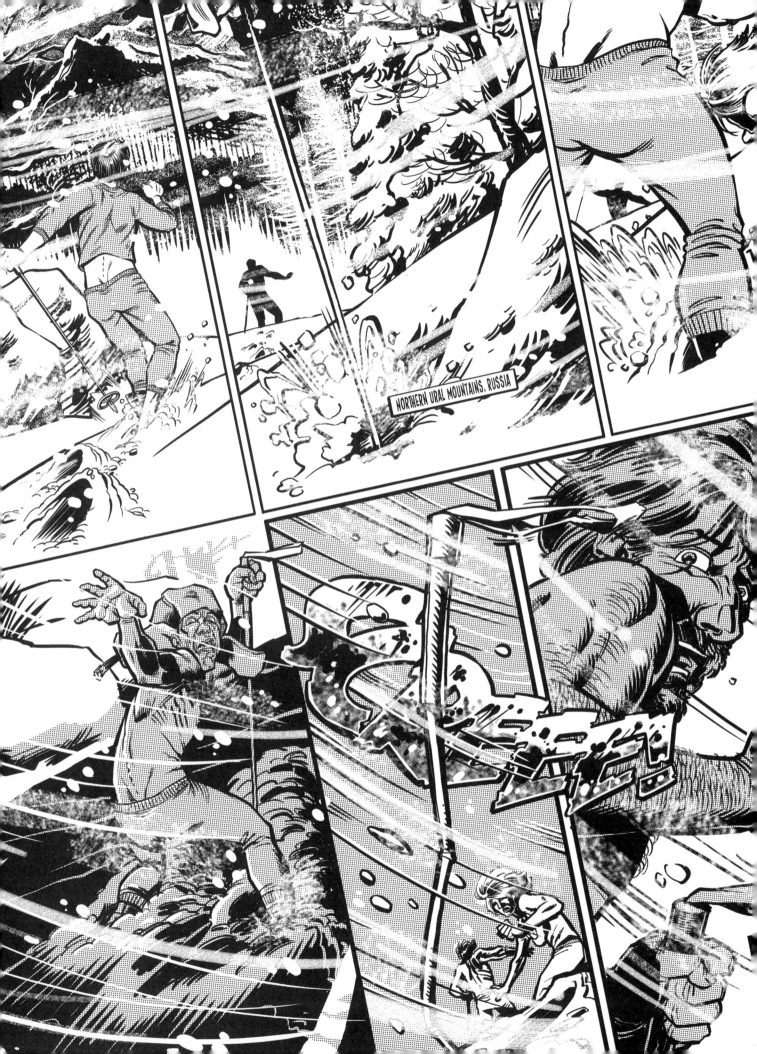

NORTHERN URAL MOUNTAINS, RUSSIA

FINDING INSPIRATION

This book will help you understand how to see the world around you and develop a working knowledge of how to apply the principles of drawing perspective. It will teach you everything, from conceptual sketches and ideas to finished illustrations.

The inspiration to draw—where does it come from? When you're drawing from your imagination, you're creating something no one has ever seen before—and that in itself is inspiring! Some artists are perfectly content to have no rules to follow, but for those who want to improve their drawing skills, both from real sources and imagined images, then learning a few principles of perspective will set you on that path.

Draw anything and everything from real life, copy it if you must—you're learning through this approach. From a very young age, I loved to draw. I was inspired by the artwork I saw in comic books, scenes from movies such as *Superman* and *Star Wars*, and photographs from magazines and books. I copied them all! Think about that: copying from seeing and copying from memory—sometimes a combination of both—to create a picture. I didn't quite understand how I came to draw from observing, but if I tried to draw from memory, I'd struggle.

Some artists, when asked to draw something like a horse, can draw it from memory; others need a photo to work from in order to render it on paper. The same thing applies to buildings, objects, and figures.

It's exciting to grab a sketchbook and go on location to draw something that inspires you to create a picture. You're developing a visual vocabulary to improve your drawing mechanics of what you see, how you draw it, and understand the process of drawing perspective for both real and imagined images. The lessons show you how to apply the principles, but still retain the flexibility of drawing in the way that you like and having fun doing it. That's the primary goal of this book: to get you involved by literally drawing in this workbook. It's yours to sketch and draw in and try out ideas of how you see the world.

▼ A scene from the graphic novel, *The Tommy Gun Dolls*. **Photo references were collected of rooms, fashion, and hairstyles as inspiration to draw this panel. The relationship between the two characters was imagined for the story, but realized through observation of images drawn and inked on paper.**

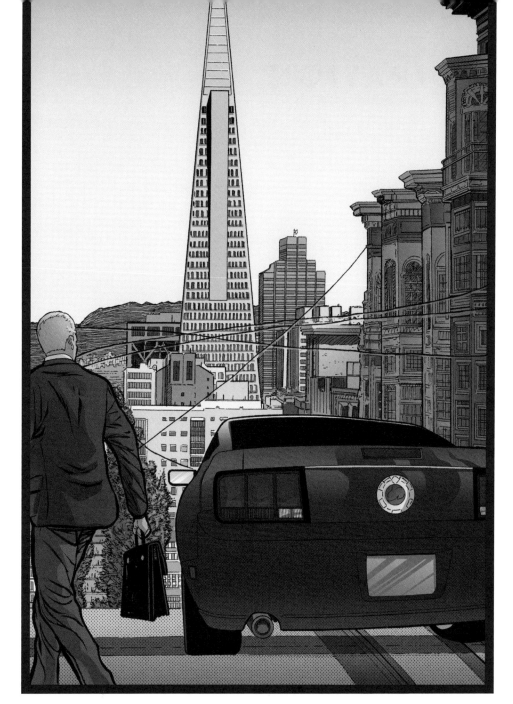

◄ This scene from *Touched* was an amalgamation of three different reference images: a photograph of San Francisco from the top of the hill, a 3-D model of a car, and the artist posing as the figure walking with the briefcase.

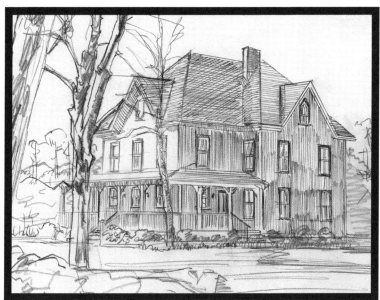

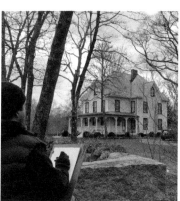

◄▲ This house was drawn on location through observation, keeping the sketching style loose and applying some variation in contour line weight, texture, and shadows.

ESSENTIAL TOOLS AND EQUIPMENT

The requirements for drawing perspective are pretty basic, but there are a few essentials that you will need in order to do it properly.

Whether you're just beginning drawing perspective or have already had some experience with it, purchase materials that are in your budget. However, keep in mind that you're investing in tools to improve your drawing skills, so quality equipment goes a long way.

DRAWING TOOLS

In pencil speak, "H" denotes hard, meaning the line will be very fine and light. "B" means soft, meaning the line will be darker and thicker. (See chart, below.)

TECHNICAL TOOLS

Templates, French curves, rulers, and compasses are your essential kit, whether you want to draw curves, ellipses, and circles consistently and accurately or to work from reference photos.

PAPER AND TRACING PAPER

There are several types of paper that are more than suitable for drawing perspective. Canson produces a series of comic-book papers perfect for penciling and inking, as well as Strathmore 500 series paper. Common paper types used are 2-ply semi-smooth and vellum surface. The semi-smooth surface is slightly

9H–7H	Extremely hard
6H–5H	Very hard
4H–3H	Hard
2H–H	Medium-hard
F–HB	Medium
B–2B	Medium-soft
3B–4B	Soft
5B–6B	Very soft
7B–9B	Extremely soft

◀ This chart gives an idea of the varieties of pencil lead available to you. Softer, darker leads such as B and 2B are generally considered best for sketching. For finished figure-work art on art boards, use harder and lighter leads, such as 2H, H, and F, to avoid smearing and smudging the lead on the paper.

▲ A clutch pencil (or lead holder) tends to use thicker leads of $\frac{1}{16}$–$\frac{1}{18}$ in. (2–4 mm). Most hold only one piece of lead at a time. Mechanical pencils come in a variety of widths: 0.7 mm (thick line), 0.5 mm (the most commonly used), 0.3 mm (fine line), and 0.2 mm (the finest of lines).

◀ ▲ A kneaded eraser that you can shape is good for cleaning up pencil smudges and unwanted construction lines. For smaller areas, use a Pentel Clic or Sanford Tuff Stuff eraser. For larger areas, use a white plastic eraser.

▲ A compass with a pencil and ink attachment is great for large circles of all sizes.

textured, making it well suited for pen-and-ink tools, pencil, specialty pens, and markers, while the vellum surface is slightly rougher, ideal for pencil rendering and drybrush effects. Try different types of paper to see which you like best. It's also good to have some tracing paper on hand, both for sketching and for refining drawings that can take a beating from erasing and redrawing.

CAMERAS

Taking photos for reference doesn't mean you have to be a professional or even take good pictures. These pictures are not going to be displayed in a gallery: they are going to be used for reference to help you improve drawing perspective. Any camera will work, from a portable mobile device or a decent point-and-shoot digital camera to a DSLR (digital single-lens reflex camera, more commonly known as a 35 mm camera).

LIGHT BOX

A light box is a useful drawing tool, but it's not essential. A light box provides a brilliant under-lighting illumination on your piece of paper, making it easier to see a drawing on top of your art board. This allows you to trace loose pencil work from sketch paper onto a tighter contour line on your art board.

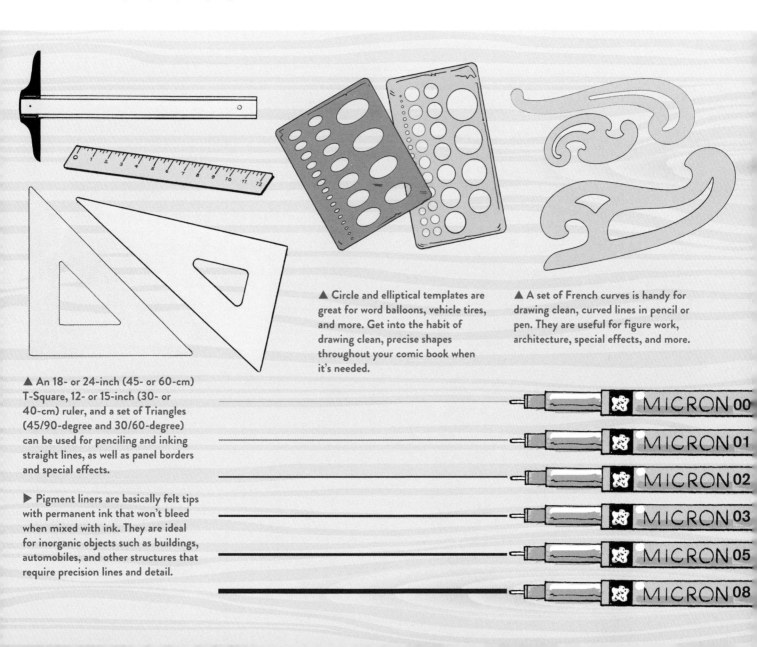

▲ Circle and elliptical templates are great for word balloons, vehicle tires, and more. Get into the habit of drawing clean, precise shapes throughout your comic book when it's needed.

▲ A set of French curves is handy for drawing clean, curved lines in pencil or pen. They are useful for figure work, architecture, special effects, and more.

▲ An 18- or 24-inch (45- or 60-cm) T-Square, 12- or 15-inch (30- or 40-cm) ruler, and a set of Triangles (45/90-degree and 30/60-degree) can be used for penciling and inking straight lines, as well as panel borders and special effects.

▶ Pigment liners are basically felt tips with permanent ink that won't bleed when mixed with ink. They are ideal for inorganic objects such as buildings, automobiles, and other structures that require precision lines and detail.

MICRON 00

MICRON 01

MICRON 02

MICRON 03

MICRON 05

MICRON 08

KEEPING A SKETCHBOOK

Sketchbooks are great for jotting down your ideas and drawing on location, whether it's outdoors or inside. It's a good habit to carry your sketchbook with you for when you want to practice drawing. With sketchbooks, you can create a theme for each one you purchase, then stow it someplace for safekeeping. For example, you could have one sketchbook dedicated entirely to old buildings, another to automobiles, one to people in a café, and so on. You're training your eye to make a proper connection between what you see and the lines you create with your hand.

IN PRACTICE: SEEING

Take a few minutes out to draw what you see, but keep it simple. Look for the diagonals of objects and use your pencil to line up those angles to find a vanishing point. This will help you to discover how your point of view dictates how you see the world in perspective.

WORK QUICKLY

Sketching quickly and confidently will give you a feel for the shapes and contours of the subject you're drawing.

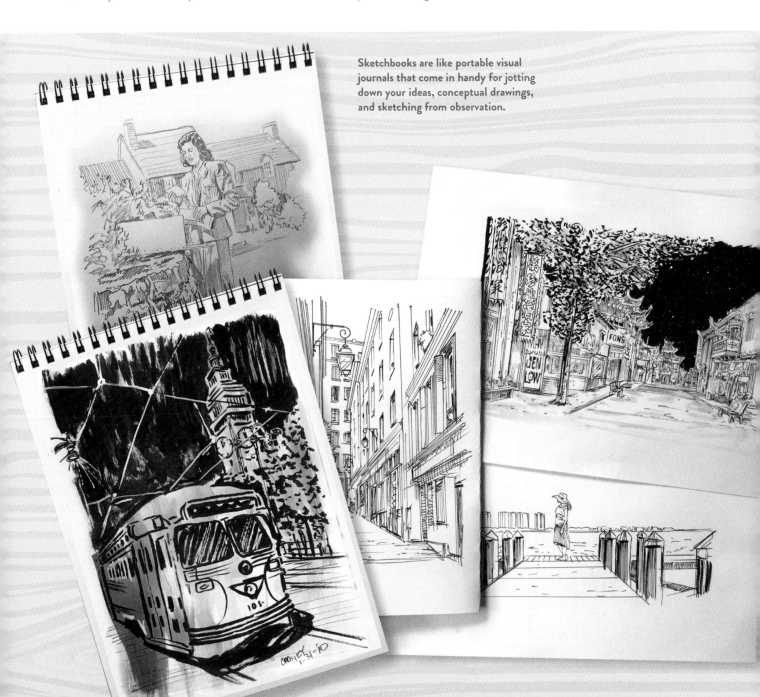

Sketchbooks are like portable visual journals that come in handy for jotting down your ideas, conceptual drawings, and sketching from observation.

ATTENTION TO DETAIL

You may find a particular aspect of the subject interesting and want to emphasize it. If you're pressed for time, take a photograph of the subject and add in the details later, working from the photo into your sketchbook.

APPLICATION

Sometimes you will find you can apply your line drawings straight into a comic book or illustrated story. Try sketching with a variety of drawing tools, from a pencil in one sketch to a ballpoint pen, watercolor and India ink to grayscale markers.

In addition to sketching from real life, you can take inspiration from old black-and-white movies—the contrast between light and dark will help you understand the shape and forms of the content.

Keep in mind to embellish your contour lines from thick to thin, adding heavier lines for subjects closer to your point of view to give the illusion of depth and emphasize the subject.

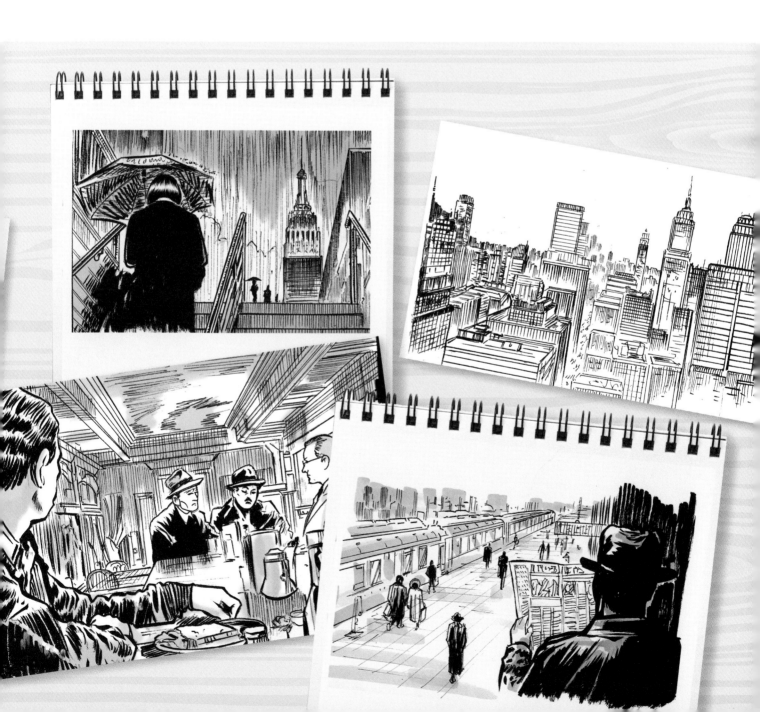

THE RULE OF THIRDS

The rule of thirds is a visual principle that you can use when composing any drawing. Here's how to use it.

Divide your picture space into thirds, both horizontally and vertically. You can do this either by lightly drawing a grid on your paper or by simply imagining the grid lines. The points where the horizontal and vertical lines intersect are the points to which the viewer's eye is instinctively drawn—so this is an effective way of directing attention to a particular part of your image. Once you're aware of how important it is to compose an image that's more pleasing and dynamic to the viewer, your drawing skills will improve.

The rule of third's origins go back to classical and Renaissance paintings and today's comic-book illustrators, painters, photographers, and artists all use it in their work on any subject matter, be it landscapes, figures, or still lifes.

▲ Illustrator Mark Schultz's *Xenozoic Tales*—featured above—is an excellent example of how compositional devices, such as the rule of thirds, can be used to lead the eye to the focal point of the image.

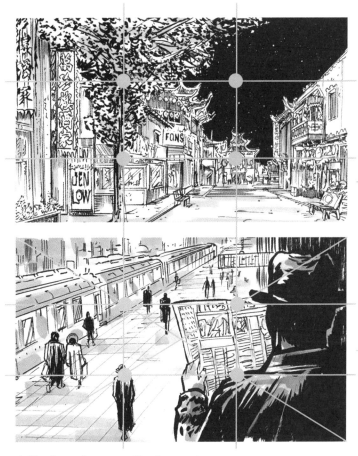

▲ The four points created by the intersecting lines in the above cityscapes are designated by the blue dots and indicate the areas of interest to the viewer.

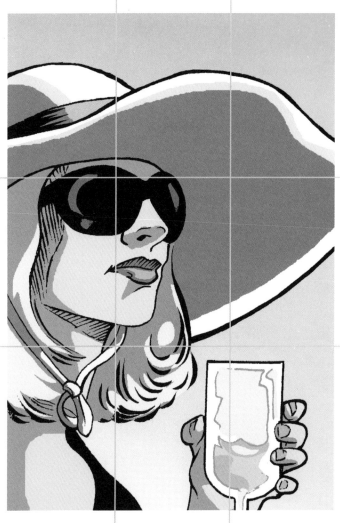

▲ In this panel, the image is arranged to draw the reader's attention to the woman's eyes—by way of her sunglasses—and her beverage. Note that not every intersection of imaginary horizontal and vertical lines needs to contain important visual material.

◀ In this comic panel, the image has been divided horizontally and vertically by four lines. The rule of thirds states that the focal point for any composition should lie somewhere along those lines.

THE BASICS: KEY TERMS

Things appear to get smaller the farther away they are. Linear perspective is simply a tool that allows you to create a sense of distance and scale in your images, and to show objects overlapping, getting smaller, or converging in an orderly way.

Perspective follows a number of rules; like all rules, they must be learned and understood thoroughly so that you can break them with surety and confidence when you need to. Gradually, as you become more confident, you will be able to plot out a few key lines and estimate the rest. This will work only if you know the rules well enough to use them. Throughout this book, you'll encounter lots of quite technical-sounding terms when talking about perspective; here's a brief guide to what they all mean.

Perspective is built upon rectangles and 90° angles. In all the examples, it should be understood that the structures drawn must either be built of 90° angles or placed inside an imaginary box.

▼ THE CONE OF VISION
This is an imaginary cone that extends 30 degrees to the left and 30 degrees to the right of a person's line of sight. It is roughly equivalent to a person's normal field of vision. Outside this 60-degree angle, objects begin to blur and their proportions become distorted. Here cube 2, which is drawn inside the cone of vision, looks correctly proportioned, while cubes 1 and 3, which are outside it, are distorted.

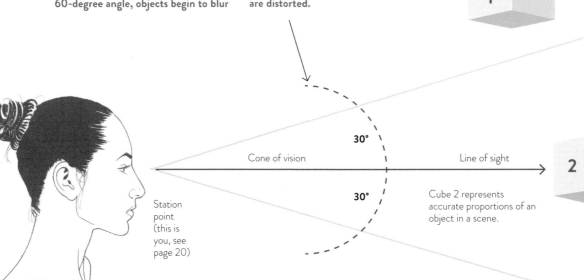

30°

Cone of vision Line of sight

30°

Station point (this is you, see page 20)

Cube 2 represents accurate proportions of an object in a scene.

▲ LINE OF SIGHT
This term applies to the imaginary trajectory from a person's eyes straight to the subject he or she is looking at.

PRO TIP
Before you begin drawing your object or scene in perspective, draw a true cube (one that is equal on all sides). If the cube is in proportion, then the objects drawn in your picture will be as well.

VP 1

HORIZON LINE

→ VP 2

VP 2 is beyond the scene and that is OK

▲ HORIZON LINE (HL)

This represents the height from which you are viewing the object or scene. Outdoors, this will be the actual horizon; indoors, it will be a line that represents your eye level. The only exception would be if you were outside, viewing from a very high or a very wide vantage point, in which case the slight curvature of the Earth would be noticeable.

▲ VANISHING POINT (VP)

This is the point on the horizon line at which parallel lines of an object (for example, a row of windows all at the same height) seem to converge. There may be only a single VP, or there may be multiple ones. These points are not fixed, but are determined by what you are seeing and where you are seeing it from (your viewpoint).

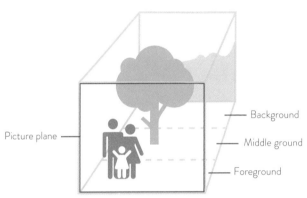

Picture plane

Background

Middle ground

Foreground

▲ PICTURE PLANE

The picture plane is comprised of three planes of depth—the foreground, middle ground, and background. Where your subject sits in the picture plane (or comic-book panel) is critical to staging the action.

VP VP

A wide field of view with vanishing points established with a right-angle station point results in a more relaxed and realistic-looking composition.

◀ PLACING THE CAMERA: ZOOM LEVEL & FIELD OF VIEW

Your field of view is determined by how close or far apart the vanishing points are on your horizon line. To understand how the zoom level works, imagine looking through a camera lens to bring your focal point closer without distorting your point of view. The vanishing points appear to close in as you zoom in and then appear to get farther apart as you zoom out. The composition doesn't change—just your proximity to the scene.

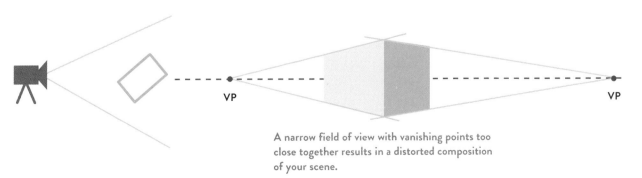

VP VP

A narrow field of view with vanishing points too close together results in a distorted composition of your scene.

THE BASICS: STATION POINT

The station point is the distance between the viewer's eyes and the picture plane. We view the world using a cone of vision (see page 18) that radiates out of each eye, converging into one focal point on a 2-D surface known as the center of vision.

In one-point perspective, the front face of any surface the viewer sees will appear in accurate proportions, without any distortion. Objects are drawn using horizontal and vertical lines, and we see facing surfaces as rectangles and squares (see illustration below)—their horizontal and vertical lines are parallel with the edges of the drawing. The sides, which appear to get smaller as they recede away from us, are converging on a vanishing point.

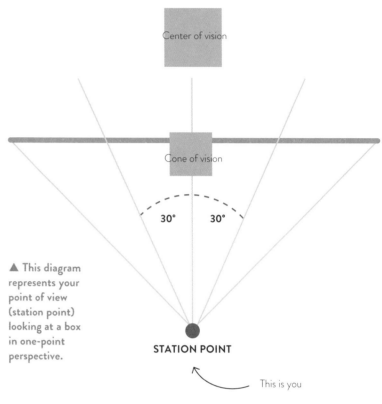

Center of vision

Cone of vision

30° 30°

STATION POINT

This is you

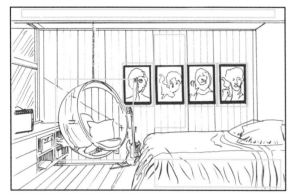

▲ This diagram represents your point of view (station point) looking at a box in one-point perspective.

◀ In this photo, note how the angles of all the diagonals on the buildings and walkway into the station recede to a single vanishing point. The photographer was standing while taking this picture and the eye level is represented by the horizon line.

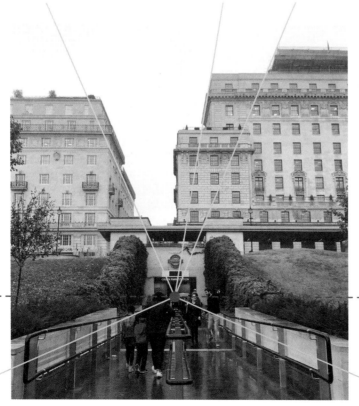

▶ Study photographs and the work of artists to identify the vanishing point(s), the horizon line, and shapes. In *Punk Taco*, a graphic novel by Adam Wallenta, note how the tilt of the composition adds a dynamic effect by adding to the illusion of movement, thus avoiding the static image that occurs when you center your vanishing point in the middle of the page.

THE BASICS: CONSTRUCTION LINES

Construction lines are temporary or imaginary guidelines that you can use to help position things within the picture space to create the illusion of 3-D objects on 2-D paper.

Construction lines may be diagonal, parallel, or perpendicular. You create them by extending a line (or lines) out from a point on your subject. Because things that are farther away from you will appear smaller with distance, diagonal lines (parallel lines receding away from you) will converge at a point on the horizon line known as the vanishing point (VP). Parallel and perpendicular construction lines, on the other hand, will remain parallel.

PERPENDICULAR CONSTRUCTION LINES
▼ These are lines that are at right angles (90°) to one another.

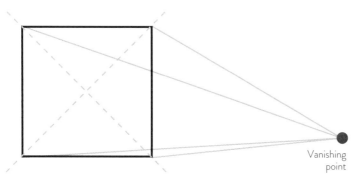

Vanishing point

DIAGONAL CONSTRUCTION LINES
◄ ► Diagonal construction lines are receding parallel lines (or rows of objects) converging at the vanishing point.

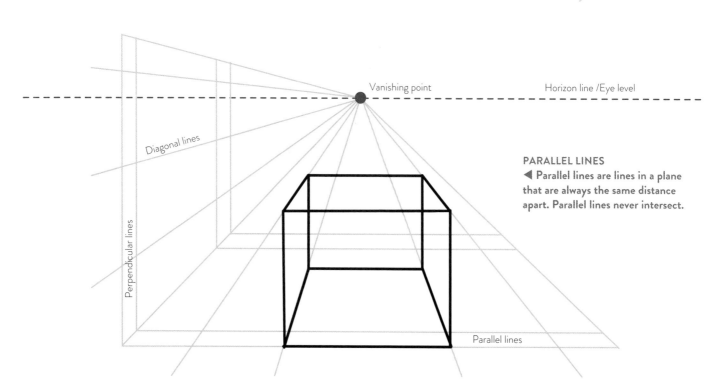

Vanishing point Horizon line /Eye level

Diagonal lines

Perpendicular lines

PARALLEL LINES
◄ Parallel lines are lines in a plane that are always the same distance apart. Parallel lines never intersect.

Parallel lines

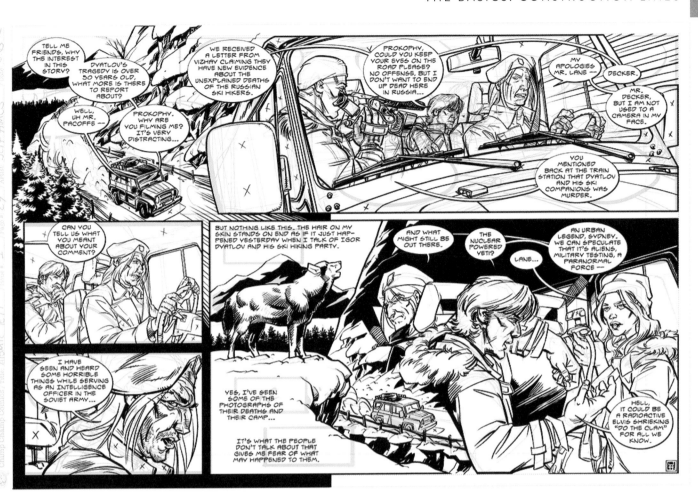

▲ Artist Jeff Himes uses blue lines to draw construction lines as a guide for illustrating compositions, as depicted here from a scene in the sci-fi horror story *The Atomic Yeti*, by Daniel Cooney.

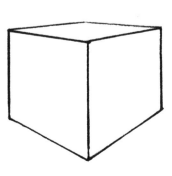

CLEANING UP CONSTRUCTION LINES

◥ Construction lines often overlap one another, making it difficult to follow a set of lines for an object. Draw construction lines lighter than the objects you are creating from them. You can use a light pencil (2H lead) and then render the final lines of the finished form in a fine-point marker or mechanical pen. This will also make it easier when it comes to cleaning up your construction lines. Another option would be to draw construction lines on tracing paper or vellum, then overlay the final art on another sheet of paper using a light box.

THREE PLANES OF DEPTH: LIGHT AND DARK VALUES

There are three planes of depth on the picture plane: the foreground, middle ground, and background.

VISUAL TRAITS OF EACH PLANE:

Foreground
- Objects appear closest to the viewer
- Objects are sharper and well-defined
- There is a higher contrast of light and shadow
- More detail is visible to the eye
- Forms are larger, with a variety of values
- Contour lines are thicker
- There is more line variation from thick to thin

Middle Ground to Background
- Objects appear farther away
- Objects are softer and less clearly defined
- There is less contrast of light and shadow
- There is less detail, "suggested" impressions
- Shapes, subjects, and forms are not as pronounced
- The values of tones are reduced
- Contour lines are thinner and less varied

Visually, we often refer to the scale of one object to another. As objects come forward in space, toward the viewer, they appear larger. As they recede into the background, they appear to get smaller in scale. The main subject (which is often in the middle ground) should dictate all of the action in the background and foreground.

CREATING DEPTH WITH CONTOUR LINE WEIGHT

A contour line in the art world is defined as a line that defines a form or an edge. Think of it as outlining an object or figure.

If you choose to create objects, shapes, and figures on three different planes, then you need to create depth through your contour line work. Adding shading with a pencil creates contrast between movable and immovable objects as well as establishing the illusion of depth, as does varying the line weight between subject and background.

Things in the background should have a lighter line weight and less detail than those in the foreground. Drawing a little more loosely in the background will also help accentuate what is occurring in the foreground or middle ground.

▶ **Attention to foreground, middle ground, and background elements is critical when you draw a scene for a comic book or stand-alone picture. Great action should have something interesting happening in the foreground (superhero), middle ground (city), and background (mountain range)—but you need to clearly differentiate the three different planes through your choice of tonal values and the amount of detail you include in order for the scene to "read" convincingly.**

PICTURE PLANE

BACKGROUND

MIDDLE GROUND

GROUND PLANE

FOREGROUND

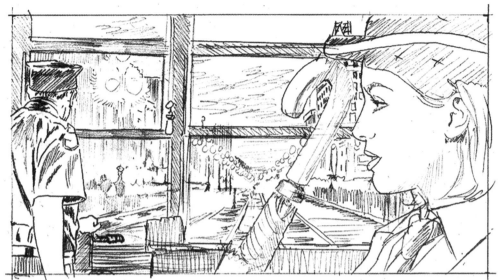

◀ This comic panel drawn in pencil illustrates the three planes of depth. Note how the contour lines in the background are thinner and less defined than those in the middle and foreground.

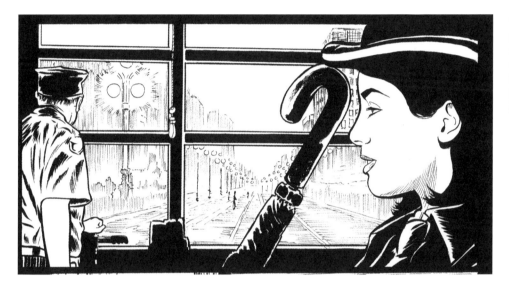

◀ A more defined version of the same panel, with markers, a technical pen, and brush, helps to establish depth by adding weight to the contour lines. Solid blacks bring the detail in the foreground and middle ground forward in the picture plane.

LINE WEIGHT SCALE

▲ Thick to thin

▲ Continuous contour line

▲ Varied line weight

▲ Added detail, variety, and overlapping

▲ The diagram above depicts how contour line weight, values, and overlapping create a sense of depth. Imagine drawing a street scene and applying the same principle to your picture, creating a three-dimensional world on a two-dimensional surface.

▲ The squares above are identical to the diagram on the left but without the overlapping, which begs the question as to which one is the closest to you and which is the farthest away. Overlapping clearly establishes the three planes of depth and makes for much more interesting compositions.

ONE-POINT
PERSPECTIVE

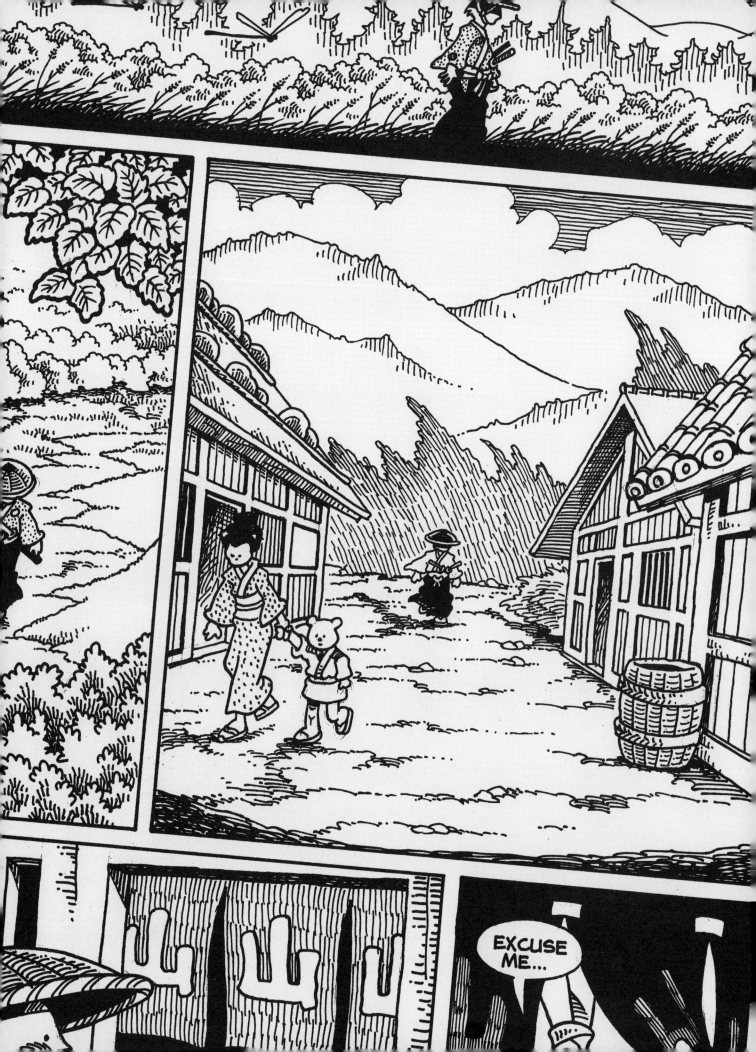

UNDERSTANDING ONE-POINT PERSPECTIVE

WHAT IS ONE-POINT PERSPECTIVE?

In order to translate the real world into one of your stories, you need to understand how perspective works. One-point perspective is based on the principle that things look smaller the farther away they are from you. Objects like roads, buildings, cars, and fences appear to reduce in size toward the horizon, converging on a single spot.

In one-point perspective, your view of an object is straight on. This means you see only the front face of any surface of an object parallel to the picture plane.

Any lines that are not parallel recede to the vanishing point.

▶ **This illustration from Linda Medley's** *Castle Waiting* **depicts a town market in one-point perspective. Notice how all the diagonal lines converge to a single vanishing point in the background.**

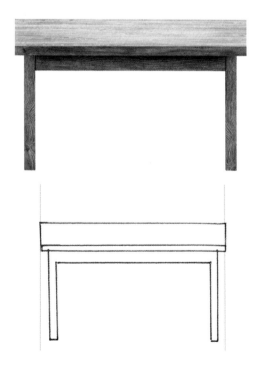

BASIC PRINCIPLES

1 The photograph above is distorted as an example of an object that does not adhere to the principles of perspective: the parallel lines do not converge away from the viewer to a vanishing point.

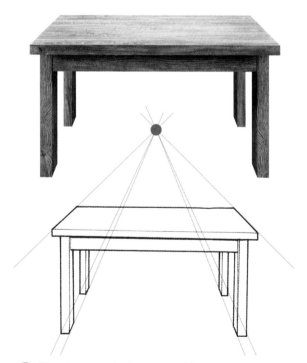

2 The photograph above is a table in proper perspective. The back edge appears to be shorter than the front because it is farther away; the parallel lines of the short edges are angled as they recede away from the viewer. In the drawing, the construction lines converge to a single vanishing point.

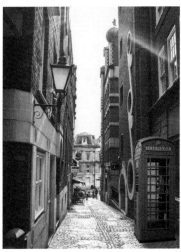

▲ The photograph above was taken at eye level from where the person was standing. The environment you're in can be a source of visual inspiration for drawing realistic or convincing imaginary scenes for a story.

PRO TIP
Lines above the horizon line slope downward while those below the horizon line slope upward.

Key
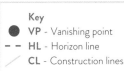
● **VP** - Vanishing point
– – **HL** - Horizon line
╱ **CL** - Construction lines

Understanding how to draw perspective is helped by understanding what you see from your point of view.

Drawing perspective is about more than just drawing boxes and shapes; it's about using a few simple principles to give your drawing depth on a flat piece of paper. While your image should be an imagined world, that doesn't mean you can't use reference material to help populate that world. You can use Google, books, and other sources to get ideas. However, you should use these references as a starting point to help create imagined objects, not as the actual objects that will populate your scene.

LOCATING THE HORIZON AND VANISHING POINT

There are two components to perspective that are important to know when drawing: the horizon and the vanishing point.

The horizon is the imaginary line between the ground and the sky. This is the foundation for every perspective drawing you do.

The point of origin for a vanishing point is usually on the horizon line. The vanishing point is the point at which parallel lines all converge. Imagine standing in the middle of a set of train tracks looking toward the horizon. You'll see that, because they are parallel lines, the tracks converge on the horizon on an imaginary vanishing point that coincides with your eye level.

It can be difficult to pinpoint the exact location of one-point perspective in the real world because our peripheral vision will alter lines that appear to bend and converge into other imaginary vanishing points, whether they seem to be on the horizon or not.

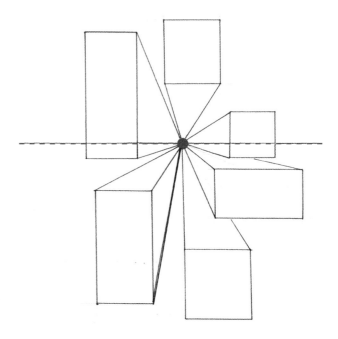

BASIC PRINCIPLES

1 In the diagram above, the vanishing point is located at the center. Try to avoid this for a couple of reasons:
- It tends to make the scene look static.
- It will not help to make your composition varied and interesting.

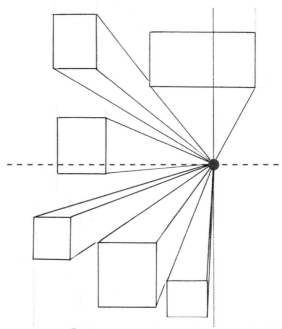

2 If you move the vanishing point slightly from the center, whether it's to the left (above left) or the right (above), both the horizontal line and the vanishing point will look a bit more natural.

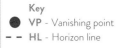

Key
● **VP** - Vanishing point
- - **HL** - Horizon line

PRACTICE HERE

Use the grid and the vanishing points to draw your own boxes in one-point perspective, as either cubes or rectangles.

DRAWING 3-D BOXES: THE BASICS

Start your exploration of the simplest form of perspective by drawing boxes. Use a pencil that gives a clean, crisp line and doesn't smudge.

1 Draw a horizon line and place the vanishing point (VP) near the middle.

2 Now draw boxes of various sizes and shapes all around the VP.

3 Draw construction lines receding to the VP.

4 Draw the back planes of the boxes. Note how only vertical and horizontal lines form the back and side planes of the shape.

5 Experiment with the thickness of each box—you'll see how the construction lines converge with the horizontal and vertical lines, giving depth to your shapes.

6 Once you've finished drawing in the forms, remove the construction lines. Regardless of your chosen medium, whether it's pencil or ink, thicken the contour lines of the boxes closest to the viewer and allow the lines to get thinner as they recede in order to create the illusion of depth.

1–2

3–5

6

▲ Like simple boxes, the side planes of vehicles work to create similar single vanishing points. Practice drawing boxes on the opposite page, then add details to transform them into cars.

Key
● VP - Vanishing point
- - HL - Horizon line
╱ CL - Construction lines

PRACTICE HERE

Draw the three-dimensional boxes
first, then make one into a vehicle.

DRAWING CIRCLES AND ELLIPSES

A circle on the picture plane of your drawing is still a circle. Once you apply one-point perspective, however, you create an ellipse. There are templates that you can use, but it helps to know how to draw one freehand. Circles and ellipses are drawn inside squares or rectangles to help get the proportions correct.

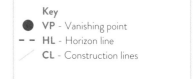

Key
● **VP** - Vanishing point
- - **HL** - Horizon line
/ **CL** - Construction lines

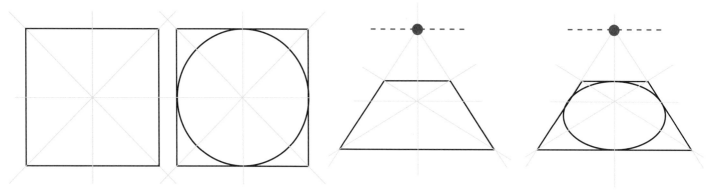

DRAWING A SIMPLE CIRCLE

1 Draw a square, then find the center by drawing diagonally from one corner to the opposite corner in both directions—X marks the spot! Now divide the square into four smaller squares.

2 Lightly sketch a circle as best as you can. It will take some practice—you want smooth curves, not pointy ones. You can use a circle template, but training your eye to draw circles freehand will improve your drawing skills.

DRAWING AN ELLIPSE—
A CIRCLE IN PERSPECTIVE

1 Draw a horizon line, then create a vanishing point. From that vanishing point, draw a line perpendicular to the horizon line.

2 Using the same method as for drawing a simple circle, lightly draw your circle in perspective. Note that the center of the ellipse is not the same as the center of the square drawn. The center of the ellipse will be closer to the viewer than the center of the square—you're creating the illusion of depth.

◀ These cylinders were constructed by drawing one ellipse for the base, with another ellipse above it, connected by vertical lines.

▶ The top and base ellipses are slightly deeper than the middle ones, as they're viewed from the highest and lowest viewpoints.

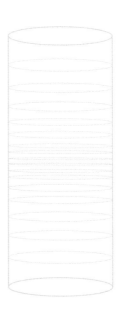

PRACTICE HERE

Draw circles, cylinders, and cones
in one-point perspective, from a
range of different angles.

PRACTICE HERE

Use straight lines (guidelines)
to help you draw irregular curves,
such as the curving forms of rivers
or trees, in a one-point perspective
landscape.

DRAW A SIMPLE ROBOT

Drawing robots is a great way to practice drawing squares, rectangles, and cylinder shapes in one-point perspective.

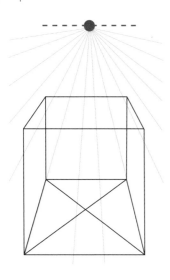
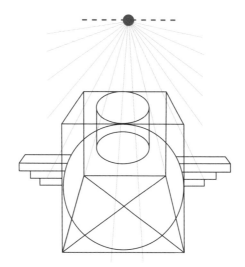
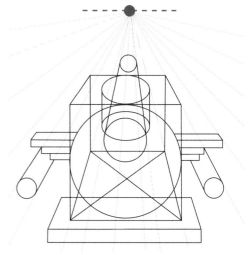

1 Create a cube in one-point perspective, then divide up the top and bottom (ground plane) evenly.

2 Draw a circle on the front face of the cube, then draw a cylinder above it. Draw rectangular shapes on each side of the circle, extending them to the VP so that they are in the correct perspective.

3 Draw cylinders under each rectangle wing, as shown. The basic shape is a front-facing cube that recedes to the VP, creating a long cylinder. Draw a rectangular flat-shaped box on the bottom. Draw a smaller circle in front of the large circle and add a cylinder behind it.

Key

● **VP** - Vanishing point

- - **HL** - Horizon line

/ **CL** - Construction lines

4 Add a couple of circles under the rectangular flat-shaped box for wheels. Remove the construction and sketch lines.

PRACTICE HERE

Draw a robot by following the
step-by-step instructions on the
opposite page.

PRACTICE HERE

Now draw the same robot
from a different angle.

DIVIDING SPACES FOR WINDOWS AND WALLS

Imagine you're drawing evenly spaced, repeated elements in a scene, such as a wall with several windows. It's vital that you learn how to divide the shapes up evenly on the picture plane.

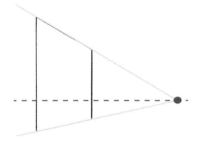

1 Establish your vanishing point on the horizon line. Create construction lines that come forward diagonally. Draw two vertical lines between the construction lines.

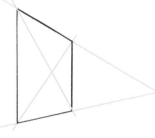

2 Now draw diagonal construction lines from one corner of the shape to the other, in both directions. The two lines intersect to create the center point.

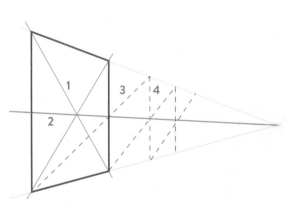

▲This one-point perspective drawing is considered a low-angle establishing shot. A composition like this hints at an exciting story that lies at the turn of the page.

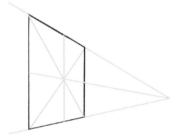

3 Divide the square into four smaller squares.

4 Repeat steps 1 and 2 in each of the four small squares. Using the vanishing point, draw additional construction lines to the new center points created by the intersecting diagonal lines in each square.

5 Clean up your drawing once you've decided how you want the rectangles/ squares divided—it's up to you.

Key
● **VP** - Vanishing point
- - **HL** - Horizon line
╱ **CL** - Construction lines

TO DRAW A SERIES OF WINDOWS
Repeat step 1. Always start your shape farthest from the vanishing point for equal shapes and division. Find the center of that shape by drawing a diagonal construction line (1) from the bottom of one vertical line to the opposite corner of the square, in both directions. Then draw a line through the center of the shape where the two construction lines converge (2) to the vanishing point. To determine the next shape toward the vanishing point, draw another diagonal construction line (3) from the bottom of the left-hand vertical line through the point where the right-hand vertical line intersects line 2 and up to the construction line that recedes from the top of the square toward the VP (4). Repeat as necessary.

PRACTICE HERE

Follow the step-by-step instructions
on the opposite page to create
windows in a high-rise building
for a cityscape.

PLACING THE CAMERA: MID-LEVEL VIEWPOINT

Mid-level viewpoints in one-point perspective are primarily defined by lines that converge on a single point in the distance, which coincides with the eye level of the viewer.

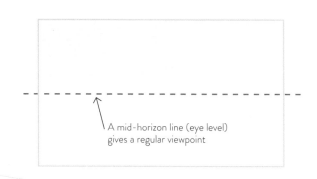

A mid-horizon line (eye level) gives a regular viewpoint

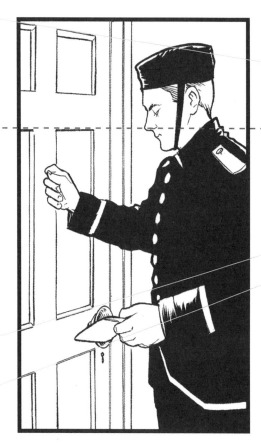

▲ Here, the bellboy knocks on the door of a hotel guest. Our point of view lines up with his as if we are standing just a few feet away from him.

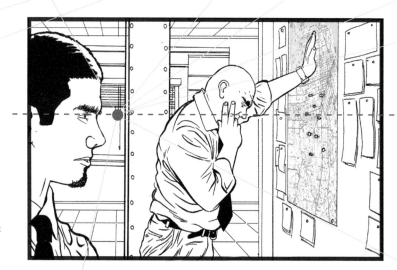

▲ A horizon line in the middle of a picture will only show the front face of any object—the top or bottom planes will not be visible.

◄ The mid-point eye level creates a composition that divides the space above and below equally in a scene.

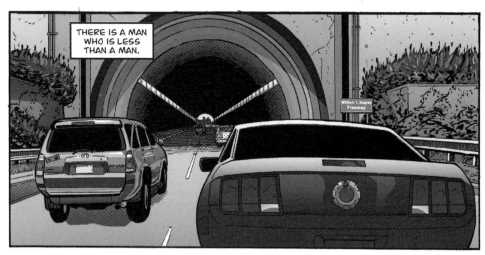

THERE IS A MAN WHO IS LESS THAN A MAN.

Key
● **VP** - Vanishing point
- - **HL** - Horizon line
╱ **CL** - Construction lines

PRACTICE HERE

Draw a hallway with doors,
windows, tile flooring, a chair
by one of the doors, and a
small coffee table next to
it with books.

PRACTICE HERE

Draw an outdoor scene, such
as a park or a pier on a lake.
You can also draw an indoor
scene, such as a throne room
in a castle. Use these layouts
as guides to come up with
your own.

PLACING THE CAMERA: LOW-LEVEL VIEWPOINT

Objects above the horizon line in the picture plane are drawn as if you are looking up at them and the bottom is visible to you. This is also commonly referred to as a "worm's-eye view."

The horizon line is drawn on the lower part of the picture plane to give a low-level viewpoint

▲ Establishing a low-angle viewpoint and tilting the composition produces a visually dynamic scene, as depicted here where the vanishing point is located just at the entryway between the two figures.

▼ Just lowering the horizon line slightly from the center of this comic panel creates a low-angle viewpoint for the reader with the characters walking through the scene.

▲ The figures in the background are the focal point, framed by the angles of the structure and the tiles on the deck that lead the eye to them.

Key
● VP - Vanishing point
- - HL - Horizon line
╱ CL - Construction lines

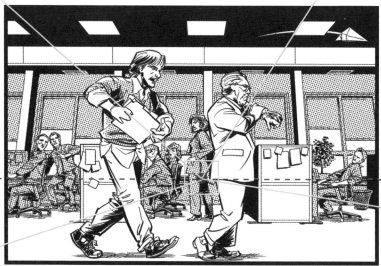

PRACTICE HERE

Draw a library with books
on the shelves, a circulation
desk, and a computer on the
counter—and try to put some
windows in as well.

PRACTICE HERE

Draw an art gallery with
framed pictures on the wall,
a bench for people to admire
the art, and some skylights in
the ceiling. Have fun with it!

PLACING THE CAMERA: HIGH-LEVEL VIEWPOINT

The examples here demonstrate the use of a high-level viewpoint, also known as a "bird's-eye view." The camera looks downward, generally from just above head height.

A high horizon line provides a large foreground area for action

▲ This high angle dictates that the vanishing point's origin is located above the horizon line.

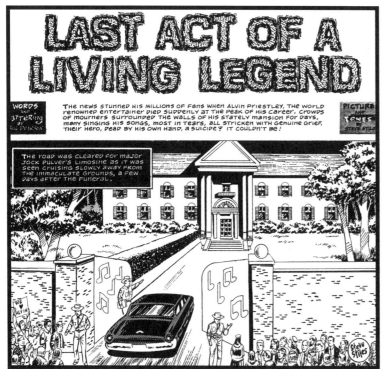

◄ The advantage of using a high-level viewpoint in your composition is that it gives you an overview of the setting and what the characters are doing. It's an effective way of engaging the reader in your story. Follow the angles with a ruler to locate the vanishing point—you'll see that it lies on top of the door.

PRACTICE HERE

Draw a factory of robots
being assembled or come
up with your own high-angle
composition.

PRACTICE HERE

Draw a cityscape of a real
or imagined city. Keep in
mind that you'll see the tops
of structures and the front
face of any object. If you like,
you can add flying cars,
billboards, elevated trains, and
pedestrian bridges that are
connected to the buildings.

DRAWING EVERYDAY OBJECTS

Let's apply one-point perspective to objects you see every day—starting with your personal belongings.

Keep in mind that objects drawn below the horizon line will have visible top planes while objects above it will have visible bottom planes.

The side planes of objects to the left or right of the vanishing point will be more visible, while objects directly above or below the vanishing point will not have any visible sides.

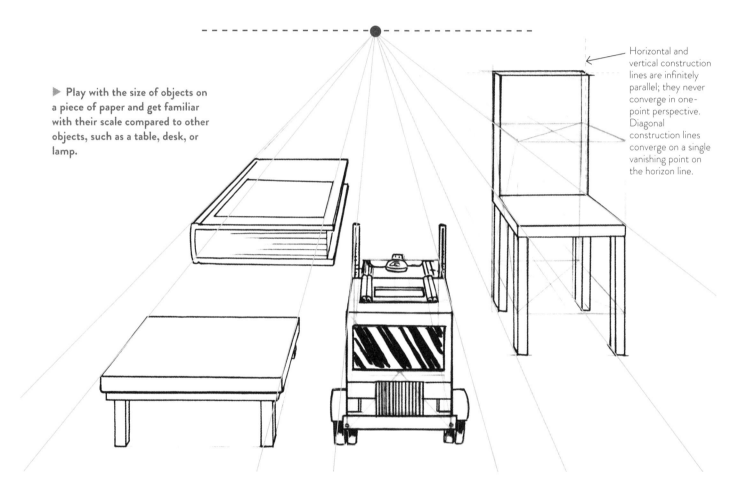

▶ **Play with the size of objects on a piece of paper and get familiar with their scale compared to other objects, such as a table, desk, or lamp.**

Horizontal and vertical construction lines are infinitely parallel; they never converge in one-point perspective. Diagonal construction lines converge on a single vanishing point on the horizon line.

▶ **In this one-point perspective drawing, the lines on the chessboard are clearly converging toward the vanishing point.**

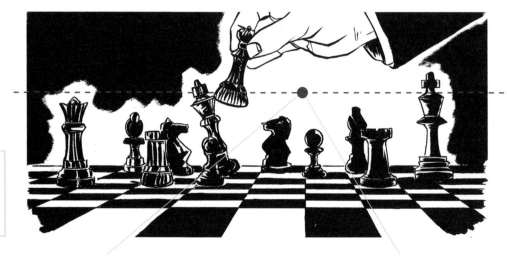

Key
 VP - Vanishing point
- - **HL** - Horizon line
╱ **CL** - Construction lines

PRACTICE HERE

Draw the same object above and below the horizon line, as well as to the left, center, and right of the vanishing point.

LITTLE SCENES

Drawing a simple scene, such as a road with a surrounding cityscape (either imagined or observed from real life), is a great follow-up activity to the previous exercises.

Practice drawing the world around you. What do you see? Sit in the middle of the hallway of your home, on a pier looking toward the horizon, or in a place that has clear rectangular shapes in it. Draw what you see.

Locating the vanishing point from where you're standing takes a little practice. A helpful tip is to stand facing toward the horizon and follow the diagonal construction lines. Your peripheral vision will have them converge into a single point.

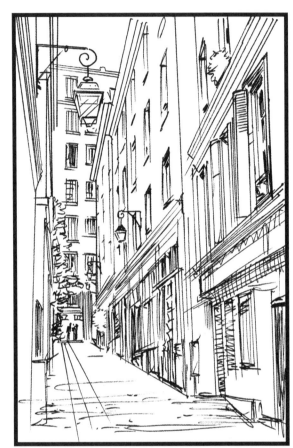

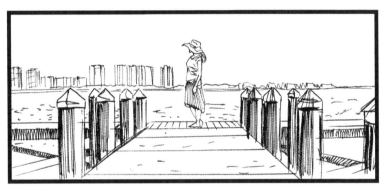

▲ As you can see in the drawing of the woman standing on the pier, the vanishing point is in the center.

◥ One-point perspective is a handy principle in drawing scenes like this one of the alley from the character's point of view.

▶ This angle places the viewer on the railroad tracks, making for an engaging composition in the context of a comic book page.

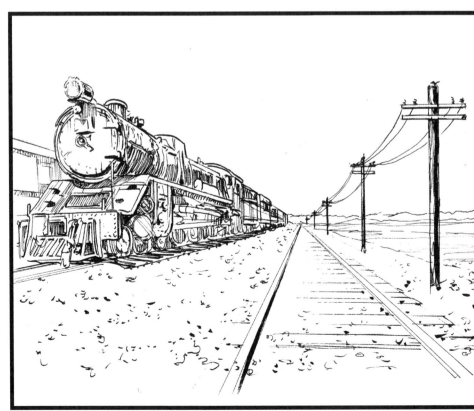

DRAW IN A SIMPLE SCENE

Each box has the vanishing point at different locations. You could practice the same scenes as shown opposite or start with something familiar to you, such as a hallway outside your classroom.

DRAW AND FILL-IN

You have been introduced to the principles of one-point perspective in drawing objects from various angles, dividing space for evenly spaced elements, and using ellipses as a guide for drawing objects in the round and curved planes in structures. Now apply those principles and add your own objects to this unfinished drawing—or trace over the objects to gain a better understanding of one-point perspective in a scene.

PRO TIP
Remember: In one-point perspective, the horizontal and vertical lines are infinitely parallel to one another, while the diagonal lines recede to the vanishing point.

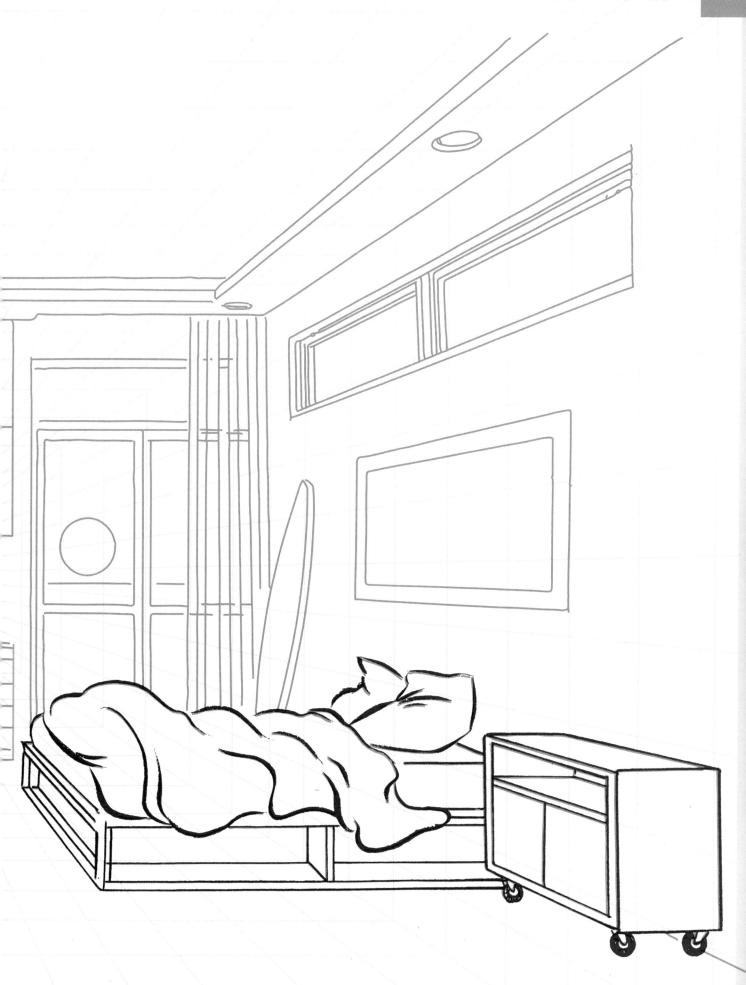

COMPLEX FORMS

Create a one-point perspective drawing of stacked blocks in a variety of sizes. Draw blocks that have holes cut out of them. Use construction lines from the vanishing point to the object in order to find the back edge of the cutaway area. Slice away sections from the blocks and/or add asymmetrical shapes.

BLOCK LETTERS

Practice drawing block lettering:

Above the horizon to the right
Above the horizon to the left
Below the horizon to the right
Below the horizon to the left

COMPLETE A LINE
DRAWING OF A STREET

Your street scene can be from any
period—past, present, or future. Just
make sure the sky is visible.

DRAW A PIER

Use rectangles, cylinders, and squares to create a pier made up of wooden planks supported by posts overlooking a pond, harbor, or lagoon in one-point perspective. You can draw rectangles vertically in the background on the horizon for buildings or trees, or triangles for mountains, boats floating in the water, maybe even one or two anchored and tied to the posts on the pier. This exercise encourages you to structure your composition with basic shapes before adding embellishments to turn them into recognizable objects.

DRAW A CHECKERBOARD AND GAME PIECES

Place the board on a table in a booth near the window of a diner. Out the window you can see a road perpendicular to the main road, with telephone poles receding to the horizon line. Establish your vanishing point on the horizon line and determine your point of view.

TWO-POINT
PERSPECTIVE

UNDERSTANDING TWO-POINT PERSPECTIVE

WHAT IS TWO-POINT PERSPECTIVE?

Two-point perspective can be used to draw the same objects as one-point perspective, but instead of viewing an object up or down, you can view it from side to side as well.

In one-point perspective, one set of parallel lines from a single plane converges to a single vanishing point; in two-point perspective, two planes of an object are visible, each with its own set of parallel lines converging to a separate vanishing point on the horizon line.

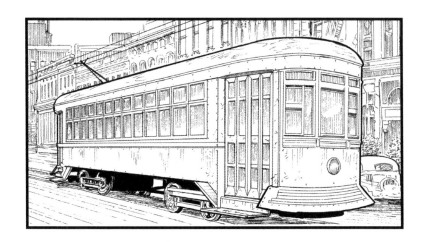

▲ The streetcar depicted here is an example of two-point perspective. Break down the object into simple shapes and you'll find both vertical and horizontal rectangles, as well as ellipses in the wheels.

BASIC PRINCIPLES

1 The robot above is depicted in proper perspective. Two planes are visible: the front and the side of the robot. Note that the construction lines are angled, as the object appears to get smaller the farther it is away from the viewer, and recede to different vanishing points—one on each side.

2 The robot above is distorted, as it has not been drawn following the principles of two-point perspective: the construction lines of the top and front do not converge properly to their respective vanishing points.

Key
- ● **VP** - Vanishing point
- – – **HL** - Horizon line
- / **CL** - Construction lines

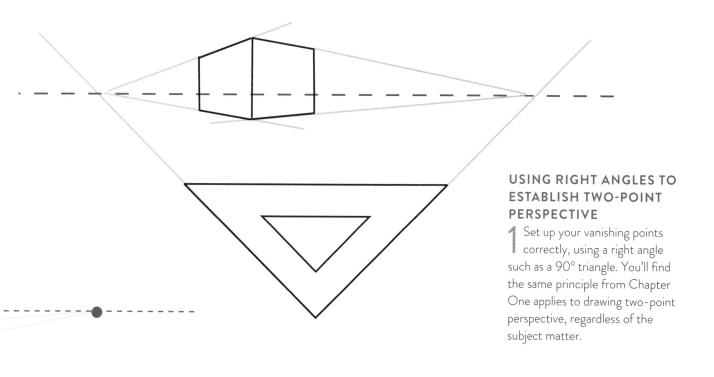

USING RIGHT ANGLES TO ESTABLISH TWO-POINT PERSPECTIVE

1 Set up your vanishing points correctly, using a right angle such as a 90° triangle. You'll find the same principle from Chapter One applies to drawing two-point perspective, regardless of the subject matter.

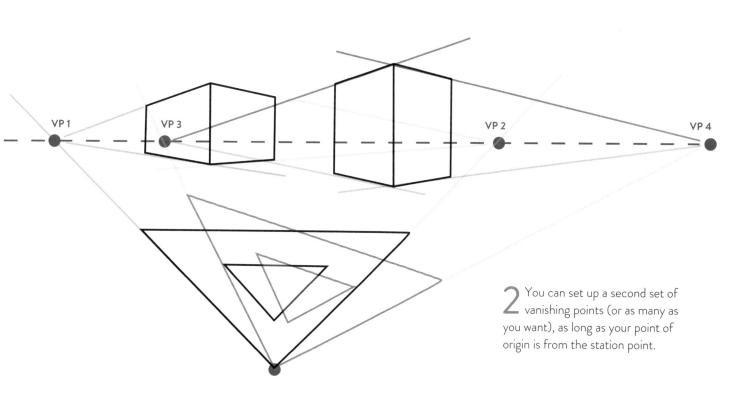

2 You can set up a second set of vanishing points (or as many as you want), as long as your point of origin is from the station point.

LOCATING THE VANISHING POINTS

When locating vanishing points in a two-point perspective view of an object or structure, both sets of construction lines will appear to recede to vanishing points on the horizon line, but the vertical lines will all be infinitely parallel to one another.

1 A visual key in locating the vanishing points in two-point perspective is to study the angles of the sides of the object. The example to the right has wooden blocks above and below the horizon line (eye level), with the vanishing points extended beyond the page. Understanding visual depth is learning to see how vertical edges appear to get smaller as the nearest one to you remains the tallest. The sides of an object appear to diminish in size as they recede into the distance.

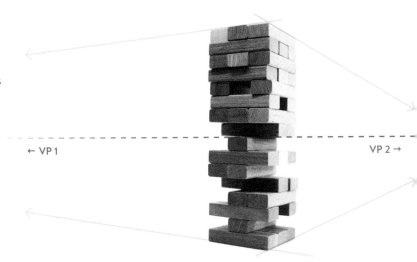

← VP 1 VP 2 →

VP 1 VP 2

2 If your viewpoint of an object is above or below the horizon line (eye level), the lines would still recede to the same vanishing points on the horizon line.

← VP 1 VP 2 →

3 The facing side of an object tends to have lines almost parallel to the horizon line that recede to a vanishing point beyond the page, whereas the side that is less visible has a sharper incline of lines to the vanishing point, which is closer to the object.

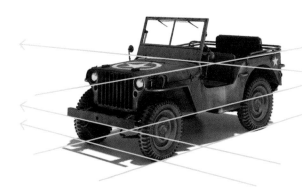

Key
● **VP** - Vanishing point
- - **HL** - Horizon line
╱ **CL** - Construction lines

PRACTICE HERE

Find the vanishing points of each object
by using a ruler or triangle along the
receding sides and drawing a line until
they converge.

DRAWING ONE 3-D BOX

When drawing, keep in mind you're creating a picture on a two-dimensional surface. To add realism to your drawings, your aim is to create an illusion of a three-dimensional space.

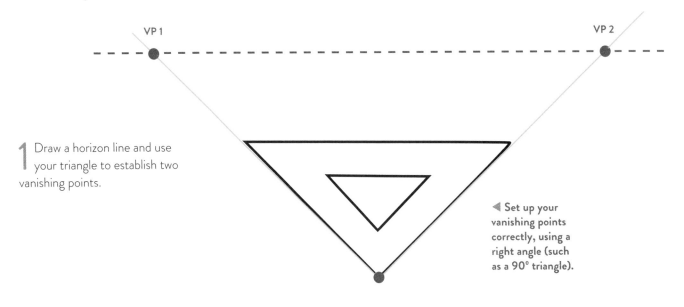

1 Draw a horizon line and use your triangle to establish two vanishing points.

◀ **Set up your vanishing points correctly, using a right angle (such as a 90° triangle).**

2 Now draw a box using your vanishing points on the horizon line, above it or below it. Draw construction lines receding to the vanishing points. Use the front-facing two sides to establish the back planes of the box by drawing through to each vanishing point, keeping in mind that the vertical lines remain perpendicular to the horizon line.

3 Once you've finished drawing the box, remove the construction lines. Regardless of whether you work in pencil or in ink, embellish the contour lines, allowing the lines to get thinner as they recede to create the illusion of depth.

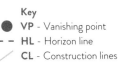

Key
VP - Vanishing point
- - **HL** - Horizon line
⁄ **CL** - Construction lines

PRACTICE HERE

Practice drawing a cube positioned above and below the horizon line, using two vanishing points.

PRACTICE HERE

Determine where the vanishing points are placed as well as the horizon and construction lines when drawing shapes that are above, below, and on the horizon line.

DRAWING MULTIPLE 3-D BOXES

USE THE CENTER OF VISION TO ESTABLISH THE VANISHING POINTS

Your drawings will look more interesting as you integrate both one-point and two-point objects into your composition, just as long you understand how to set up one-point perspective using your center of vision before establishing your vanishing points for two-point perspective.

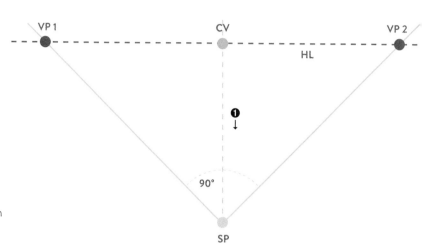

1 Draw a horizon line and place a center of vision point (CV) on it.

2 Draw a line perpendicular to the horizon line ❶ from your CV to a station point (SP) to establish your vanishing points from a 90° angle.

3 The lines that intersect at the horizon line from the station point (SP) are your vanishing points.

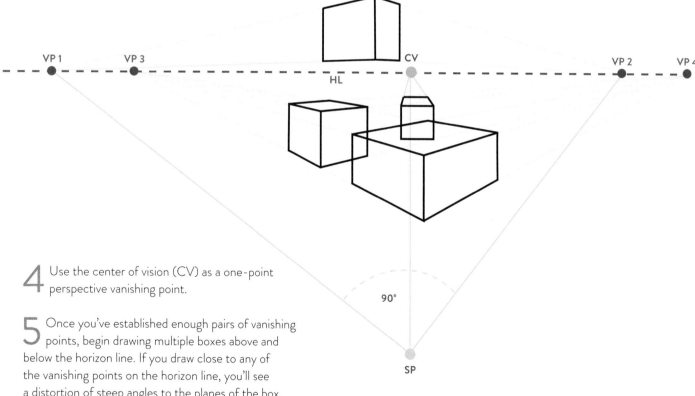

4 Use the center of vision (CV) as a one-point perspective vanishing point.

5 Once you've established enough pairs of vanishing points, begin drawing multiple boxes above and below the horizon line. If you draw close to any of the vanishing points on the horizon line, you'll see a distortion of steep angles to the planes of the box. To avoid this, keep your boxes within the cone of vision to maintain a convincing shape without looking like it's distorted.

Key
- ● VP - Vanishing point
- – – HL - Horizon line
- ╱ CL - Construction lines
- ● CV - Center of vision
- ● SP - Station point

PRACTICE HERE

Draw multiple cubes in two-point perspective. The SP has already been established from the CV and you can add a second set of vanishing points by using your triangle, pivoting from the SP and drawing lines that intersect with the horizon line to create your vanishing points.

What happens if you draw a cube outside the CV? Try a few boxes and you'll see how distorted they become the farther away from the CV they are.

DRAW A SCENE FOR YOUR COMIC

Determine where your horizon is placed, then place a CV before drawing a vertical line to an SP to set up your vanishing points. Construct a scene of an interior or exterior location that could serve as the first scene in your story.

INCLINED PLANES

The house (right) is viewed in two-point perspective, as we can see two planes—the side and front of the building. We can also see two planes of the roof and the narrow sliver of the eaves, which are parallel to the front façade. However, because these planes are inclined (i.e., angled) to create the pitch of the roof, from a perspective point of view they need to be treated as a separate entity, each with their own vanishing point.

▲ Learning how to draw the inclined angles of the roof depicted here will build on your skill set.

DRAWING A BASIC HOUSE AND ROOF

1 Using the skills you learned in Drawing One 3-D Box (see page 68), draw the basic shape of a house in two-point perspective, with two vanishing points, VP1 and VP2. Make it transparent, so that you can see all the walls.

2 Find the center of the front and back walls by drawing a line from corner to corner—you'll draw a vertical line at the intersection point of the lines. This will determine the highest point of your roof ❶.

3 Once you establish the height of the roof, draw a line from that point to VP1 to establish the angle of the roof. Then draw the angles from the point of the roof ❷ to the walls, as in step 2 above.

To establish the depth and angle of the front and rear eaves, draw two construction lines from VP3 to points ❸ and ❹.

To find the depth of the overhang of the front eave ❺, draw a line from the front eave point of the roof ❹ to VP1. This creates your overhanging eave line. Repeat the process for the back eave.

Key
● **VP** - Vanishing point
-- **HL** - Horizon line
╱ **CL** - Construction lines
● **SP** - Station point

VP 3

DRAWING THE FRONT ROOF AND EAVES
Determine how wide you want the eaves to be and then draw a set of construction lines for the front extending to VP3. Then decide how much of an overhang you want for the eaves. To do this, draw a construction line from the front of the corner roof to VP1.

VP 1

VP 2

SP

DRAWING THE BACK ROOF AND EAVES
To draw the back of the roof, create a vertical VP4 below the horizon line on the same vertical line from the inside peak of the back roof, following the angle until it intersects with the vertical line. Draw a line from the peak of your forward eave down to the VP to create the width of the back of the eave in perspective!

VP 4

PRACTICE HERE

Draw a two-point structure and add a roof.
A center of vision box has been added to
give you an idea of where to start. Keep
in mind that the closer your structure is
to the vanishing points, the more it
recedes at an extreme angle, distorting
your drawing.

DRAWING A ROBOT FIGURE

Drawing a robot in two-point perspective furthers your drawing skills in rendering objects in convincing and dynamic ways, giving depth to the figures in your compositions.

The robots illustrated here are based on a two-point perspective principle, drawing the subjects within the center of vision using basic shapes.

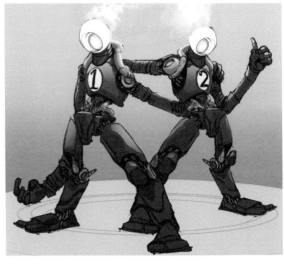

▲ Designing a robot can be fun when you use a variety of shapes, such as cylinders, cones, rectangles, cubes, and ovals, in two-point perspective.

VP 1 VP 2

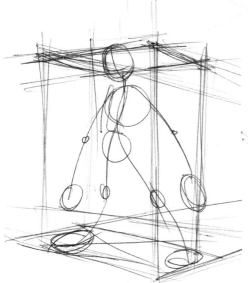

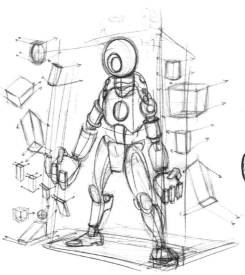

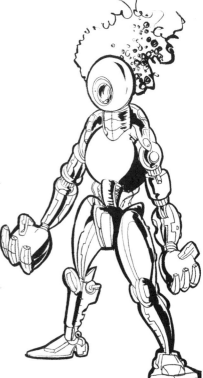

1 Establish your drawing by creating a horizon line with two vanishing points using a triangle. Keep your sketches loose and do not be concerned with details at this stage. Lightly sketch construction lines to your vanishing points, just as a guide to keep the robot in perspective. Use a wire frame/ armature to sketch a pose you'll be happy with before adding details and heavier contour lines.

2 Once you're satisfied with the design, start embellishing your contour lines to define the limbs, torso, and head. Every shape used has a set of construction lines receding to one of the two vanishing points.

3 Refine the sketch, outline the line work you're happy with, and erase the pencil sketch lines before adding in the details and trying out some color!

PRACTICE HERE

Draw a robot in a setting, using two-point perspective. As an aspiring storyteller, consider the three "Ws" of a scene:

Who is your character (robot)?

What is your character doing?

Where does this scene take place?

Think about the environment your character acts in, too: is it outer space on a space station, on an alien planet working in a garage, or flying a ship?

Key
 VP - Vanishing point
HL - Horizon line
CL - Construction lines

DRAWING A HUMAN FIGURE

If you think of the human body as being made up of basic shapes, it will give you a solid, three-dimensional form to build your characters in one-, two-, and three-point perspective (see Chapter 3). It will also enable you to create convincing figures in any setting.

THINKING IN SHAPES

Similar to drawing boxes and other simple objects in perspective, thinking of the human figure in terms of simple, basic forms makes it easier to understand the separate parts and place them in their proper relationship. The figure consists of six basic parts—the head, the torso, two arms, and two legs. As a comic book artist, you will not be held to the strict rules of anatomy. You may lengthen, shorten, or otherwise distort any part of the figure you please, especially if it will help you portray the character you are trying to create. But regardless of your drawing style or exaggeration, you should adhere to the principles of three-dimensional form. With a solid form to build on, adding figure details and clothing is greatly simplified.

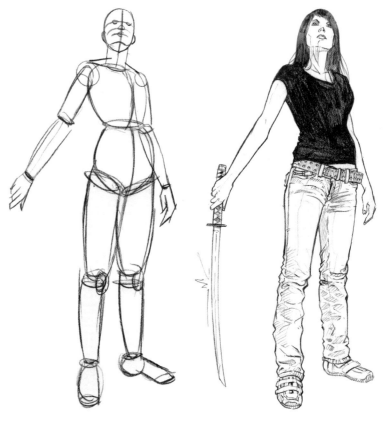

◣ DRAWING THROUGH

When drawing the basic figure, you must "draw through" to the other side—meaning that you should draw the figure as if it were transparent. Even though a shoulder or arm may be hidden by another part of the body in the finished drawing, you must be aware that they exist. When all of the figure parts are accounted for by "drawing through," the end result will be a figure that is convincing in structure and action.

▲ ANATOMICAL SHAPES

The basic figure can be reduced to a series of cylinders and spheres. These shapes simplify the body to its essential masses, eliminating every distracting element. Think of the figure as if it were carved out of heavy wood—it is solid, three-dimensional.

▲ FINISHED DRAWING

Even when you add detail in the finished pencil drawing, you will see how the neck, arms, legs, and rib cage are essentially modified cylinders. A simplified anatomical underdrawing is essential for creating a convincing figure.

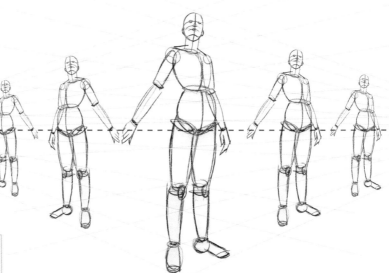

Key
● **VP** - Vanishing point
- - **HL** - Horizon line
/ **CL** - Construction lines

PRACTICE HERE

Simplify the figure by drawing over it, using a variety of cylinders and spherical shapes. Your drawing should look something like the image to the right.

Draw a few human figures in the two-point perspective grid using only basic shapes. Feel free to try some different poses. Note how the smaller figure is in proportion with the foreground figure on the horizon line.

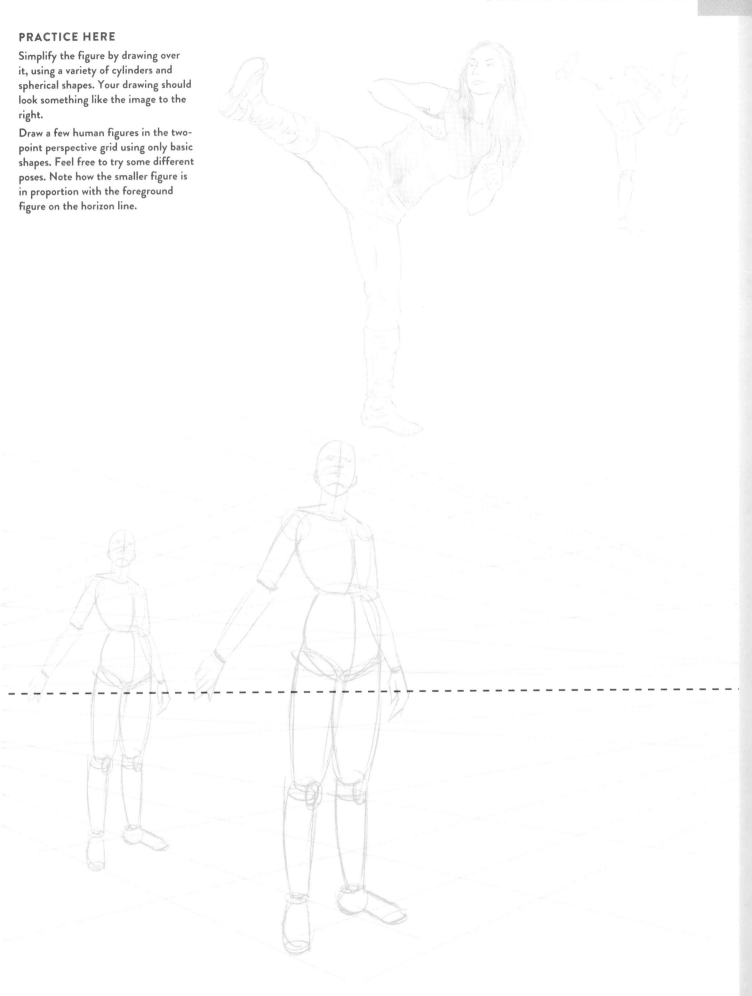

DIVIDING SPACE

One of the most challenging aspects of drawing in perspective is figuring out the distance between evenly spaced objects of the same size that appear to get closer together as they recede toward the horizon line—for example, fence posts or telephone poles.

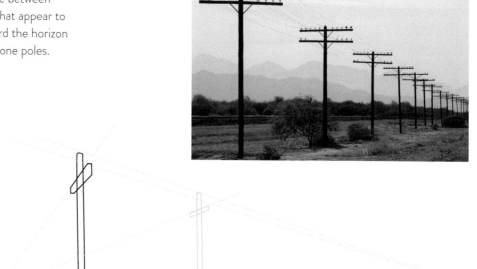

1 Draw a horizon line (HL) and establish two vanishing points (VPs) on it using a triangle. Draw a vertical line through the HL close to VP1. Draw a construction line to VP1, then draw a post to establish your telephone pole. For the cross at the top of the pole, decide where best to draw a line that goes to VP1. The short facing side will be created by a line drawn to VP2. Draw a second pole to the right of the first.

2 Draw a construction line from a point halfway up the first pole to VP2. Draw a construction line from the top of the first pole through the center of the second pole until it meets the bottom construction line at the ground. This point marks the spot for your third pole. Be sure that the top of the third pole does not go beyond the top construction line. For every pole you draw, the horizontal lines that make up the cross will be drawn to VP1 (the long side) and VP2 (the short side).

3 Repeat these steps as many times as you like.

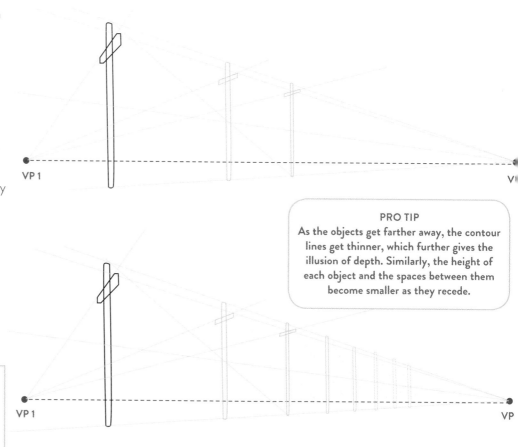

PRO TIP
As the objects get farther away, the contour lines get thinner, which further gives the illusion of depth. Similarly, the height of each object and the spaces between them become smaller as they recede.

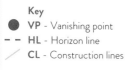

Key
- **VP** - Vanishing point
- **HL** - Horizon line
- **CL** - Construction lines

PRACTICE HERE

Establish a horizon line for two-point
perspective. Be sure to use a triangle to set
up your left and right vanishing points.

Follow the exercise on the opposite page
as a guide in drawing your own set of
columns, telephone poles, or spaces on a
wall in two-point perspective.

DIVIDING SPACE BETWEEN MULTIPLE OBJECTS

Telephone poles are tall, thin shapes, so it's relatively easy to draw them convincingly—but what if you're dealing with something wider, like a window? In order for your drawing to look proportionally correct, you need to get not only the spaces in between the objects right, but also the width of the objects themselves.

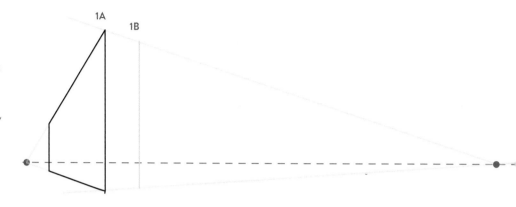

1 Draw two vertical lines (1A and 1B) to represent the width of the first object. Start dividing the space for 1A, just like the previous exercise on page 78.

2 Draw a new vertical (2A) for the next object, find the center of 1A, and apply the diagonal line method as before to set up the third object (3A).

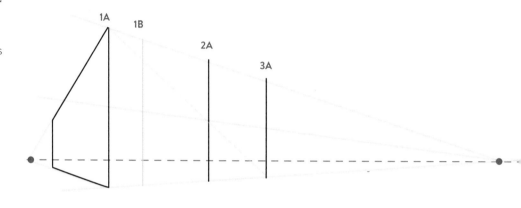

3 Draw a diagonal line from the top of 1B to the base of 3A. Then draw a line from the top of 2A through the point where the new diagonal intersects the middle perspective line. Where that line hits the bottom perspective line is the base of 2B, and you have now defined the width of the second object.

4 Repeat for each set of vertical objects separately, but do not confuse them!

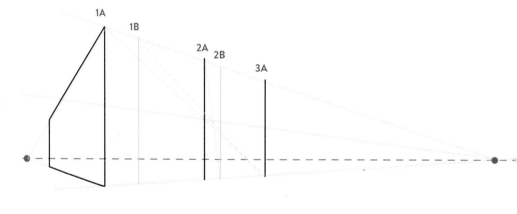

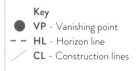

Key
- **VP** - Vanishing point
- **HL** - Horizon line
- **CL** - Construction lines

PRACTICE HERE

Establish a horizon line for two-point perspective. Be sure to use a triangle to set up your two vanishing points.

Follow the exercise on the opposite page as a guide in drawing a scene that depicts a surface, such as a wall with windows, columns, doors, etc.

Try an exterior scene, like a passenger car on train tracks in the desert—be bold and imaginative!

STRAIGHT LINES TO CURVES

Multiple sets of vanishing points from one-point and two-point perspective can be applied to drawing curves that recede to the horizon, such as roads, train tracks, river gorges, and other environments for your comic book settings.

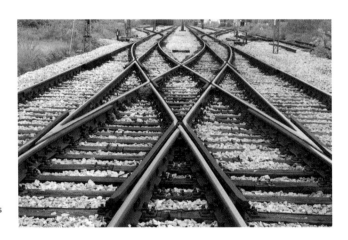

▶ **The multiple train tracks may curve and intersect but all recede to the same horizon line from the photographer's point of view. Using multiple vanishing points is acceptable when establishing straight lines to curves.**

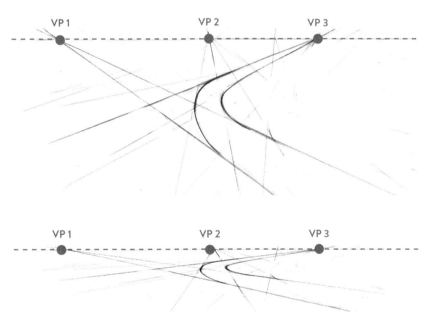

1 Determine where you want to establish the horizon line. In the example on the left, we are working with a bird's-eye viewpoint; therefore the horizon line is higher on the picture plane. Start with a loose sketch of the road you imagine, then create vanishing points and construction lines. Once you do this, draw a curved road that recedes to the horizon line to create the illusion of depth.

2 When the horizon line is lower on the picture plane (bottom left), the point of view becomes a worm's-eye angle as if you're standing on the road looking toward the horizon.

▶ **An imaginative story of a floating castle relies on the principles of perspective. Use the steps on page 70 to set up a one-point in a two-point perspective for your winding road and castle, and refer to the images above for how to use those VPs for a curved road using straight construction lines.**

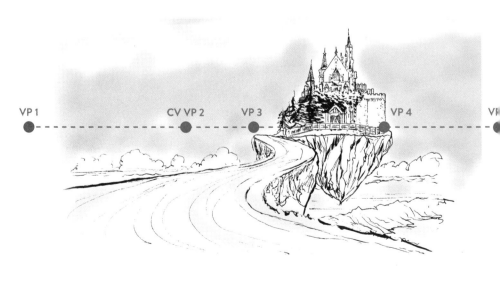

Key
● **VP/CV** - Vanishing point/Center of vision
-- **HL** - Horizon line
／ **CL** - Construction lines

PRACTICE HERE

Draw a road using the vanishing points, as
in the example on the opposite page.

DRAW A SCENE FOR YOUR COMIC

In this second exercise, determine where
your horizon line is placed:

Eye level: Middle of the picture plane

Low angle: Looking up

High angle: Looking down

Train tracks, a canyon, a river, a road
leading to a castle, or a spaceship are just
some ideas to help you get started.

PLACING THE CAMERA: MID-LEVEL VIEWPOINT

Just as in one-point perspective, the horizon line in two-point perspective represents the height from which you are viewing the object or scene. Outdoors, this will actually be the horizon; indoors, it will be a line that represents your eye level.

A horizon line in the middle of a picture will show two angles as opposed to one, with the vertical lines still infinitely parallel to one another.

You're more likely to be drawing scenes in two-point perspective because, in visual storytelling, the narrative is more often viewed from an angle than from straight on. There are two reasons for this: the composition is more interesting from an angle than having the subjects always centered, which can lend itself to static imagery that does not engage the reader, and drawing the scene from an angle gives the illusion of movement.

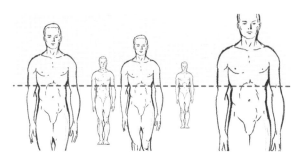

▲ Positioning figures on the horizon line (eye level) gives a regular viewpoint. Illustrator Andrew Loomis coined the term "hanging figures on the horizon line," which means having the horizon line cut through figures, keeping them on the same ground plane. Basically the line passes through figures at the same height at the same point of view. In the example above, the line cuts through the mid-section of the torso, so any figure you draw from this viewpoint will go through any figure at their mid-section as well.

▲ Two-point perspective at eye level creates a composition that is mostly equal above and below the horizon, although one angle (VP1) can be closer to the viewer than the other.

▼ The front end of the car recedes to the background, with sharper angles than the front-facing side.

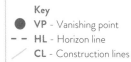

Key
● **VP** - Vanishing point
-- **HL** - Horizon line
/ **CL** - Construction lines

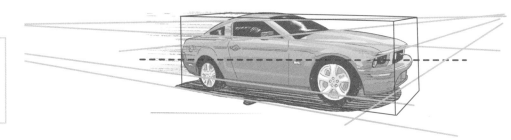

PRACTICE HERE

Draw a scene with a crowd.

You can use the "hanging horizon" method when drawing people at a farmer's market, parade, park, or at the beach.

When drawing your figures and setting, be sure to keep them proportional with one another. Also, keep your vertical lines infinitely parallel.

PLACING THE CAMERA: LOW-LEVEL VIEWPOINT

Figures that are drawn above the horizon line in two-point perspective create a low-angle viewpoint, more commonly referred to as "worm's-eye view." This angle creates engaging compositions in comic book panels from the point of view of the character, but puts the reader into the scene as well so they too can experience the action.

▲ A low-angle composition features a horizon line that goes down as you look up—note the horizon line cuts through all the figures at the same point and at the same height, creating a convincing illusion of some figures in the foreground and some receding to the background.

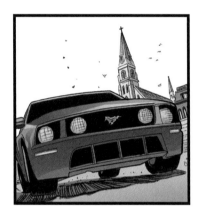

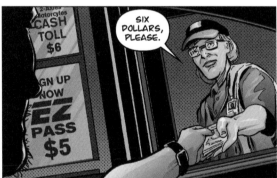

▲▲ The low angle, the tilt of the composition, and the speeding car all combine to engage the reader in the action of the scene.

▲ The subtle use of the low angle gives the reader the same point of view as the character—the driver handing money to the tollbooth collector. The vanishing points lie beyond the edges of the panel.

▶ The low angle of the building gives the reader the same viewpoint as the character in the comic book who is witnessing the scene.

PRACTICE HERE

Draw a worm's-eye view scene using two-point perspective.

Include figures, objects, and buildings seen from a low angle.

Try to have one of the vanishing points within the scene while using a T-square or long ruler to establish one beyond the confines of the page.

PRO TIP
Tape a piece of paper to your comic page when extending the vanishing point(s) beyond the panel border to locate and mark the VP on it.

PLACING THE CAMERA: HIGH-LEVEL VIEWPOINT

When constructing a bird's-eye view it is important to determine how high above a subject or scene you want your readers to be when viewing the composition, and how well the angle serves the story.

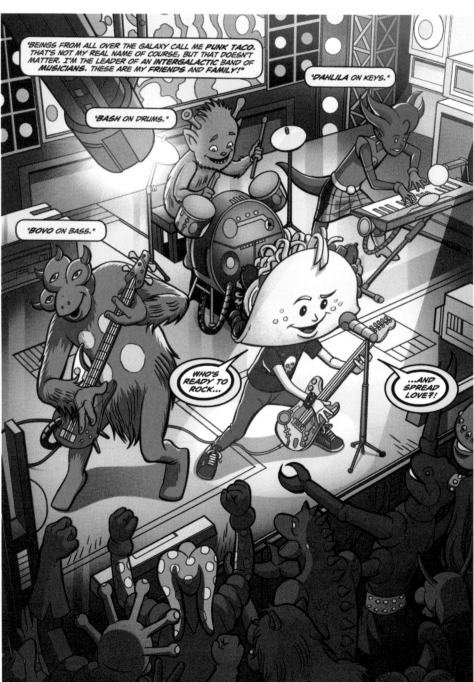

▲ A bird's-eye view features a horizon line that goes up as you look down—note the figures "hanging" as the line cuts through them all at the same point and at the same height, creating a convincing illusion of some figures being in the foreground and some receding into the background.

▲ The height varies depending on what you're trying to establish in a composition for your reader to understand. Generally, vanishing points and the horizon line are beyond the panel borders, as depicted here.

◀ Bird's-eye view compositions give the reader a scope of elements that make for an engaging scene in a story. In two-point, the angles converge to one of two vanishing points beyond the borders of the image; the vertical lines are infinitely parallel. The musicians in the band are the focal point. This angle involves the reader from the point of view of a spectator in the balcony.

PRACTICE HERE

Draw a bird's-eye view scene, looking down from a rooftop at characters on a street corner. Include figures, objects, and buildings—use your imagination!

LITTLE SCENES

Drawing a simple scene in two-point perspective like a battlebot with a surrounding cityscape (either imagined or observed from real life) is a great follow-up activity to the previous exercises.

Drawing environments that are familiar to you and enable you to work from observation can be beneficial in rendering real or imagined scenes that tell a story from ANY angle.

▶ An interior scene, such as a room with some of your favorite possessions, shown slightly below the eye level of the woman getting ready for a social event, gives your character something to do.

▼ A low angle seen from the character's point of view is a fun way of showing what is happening in a scene, such as this cow being abducted by an alien spacecraft. Note the use of ellipses to establish the spacecraft in perspective.

▲ Sports cars having a race is another exercise in simulating movement from a low-angle viewpoint with the action speeding toward the viewer; no background is necessary for this scene.

PRACTICE HERE

Draw a simple scene.

Each box has the vanishing points at different angles: high, eye level, and low. You could practice the same scene from different angles or start with something familiar drawn from observation.

DRAW AND FILL-IN

You've been introduced to the principles of two-point perspective for creating objects from various angles, dividing space, drawing robots, and human figures so let's put them to the test!

• Add your own objects into this unfinished drawing—for example, more businesses, windows above, a billboard or sign, cars, trucks, people, etc.

• Find the vanishing points by taping additional paper to the edge of each page, where the blue construction lines intersect for VP1 and VP2; mark it and begin adding your own construction lines.

PRO TIP
Use the "hanging horizon" method to establish people walking, riding bikes, sitting at a sidewalk café, etc.

DRAW A LOW-ANGLE SCENE

This is your opportunity to draw
a scene from your comic book
incorporating all the exercises in
this chapter. Use the three "Ws"
of storytelling to set up your scene:
WHO is involved, WHAT are they
doing, and WHERE does this scene
take place?

DRAW AN EYE-LEVEL SCENE

Draw the same scene again, but this time from eye level, where the horizon line divides your composition in half. Generally, comic book artists sketch out the same scene or sequence of events from different angles to fine-tune their composition and find the one that best serves the story. As before, use the three "Ws" of storytelling to set up your scene.

DRAW A HIGH-ANGLE SCENE

Draw the same scene again, but this
time from a bird's-eye view. If you
choose to do this, what is different
from the low angle and the one drawn
from eye level? How does it impact
the focal point (your character or the
action) of the scene?

PRACTICE HERE

Draw a subway station in two-point perspective. Choose any viewpoint: high angle, eye level, or low angle. In your station, there should be a tunnel with either the subway approaching or already at the platform with the doors open. Think of details, like signs on the walls and hanging from the ceiling, turnstiles, a ticket agent booth, trash cans, benches for passengers, etc.

PRACTICE HERE

Draw a spaceport in two-point
perspective. Choose any viewpoint:
high angle, eye level, or low angle.
Imagine a spaceship of your design
parked on a landing platform.

3

THREE-POINT
PERSPECTIVE

UNDERSTANDING THREE-POINT PERSPECTIVE

WHAT IS THREE-POINT PERSPECTIVE?

Three-point perspective is applied when the viewpoint is higher or lower than in a two-point view. The verticals in the composition recede from the viewer, so they need a vanishing point of their own.

In three-point perspective, none of the planes of an object is parallel to the picture plane. Three-point perspective visualizes extreme height or depth—objects and structures are well above or well below eye level, which can result in highly dynamic images for your comic book.

▶ The vanishing points in this composition go far beyond the picture plane to achieve this dynamic angle. The illustration of the zombie attack is drawn within the center of vision to avoid a distorted image.

▼ In this sketch by George Huszar, construction lines to the vanishing points help to establish line work for the composition to keep the objects in perspective.

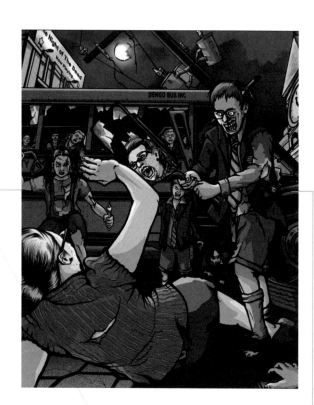

ESTABLISHING THREE-POINT PERSPECTIVE

1 Draw a line and measure the length using a compass to mark each end.

2 Keep one point of the compass on one end of the line as you pivot the other point down.

3 Repeat this step at the other end of the line to create two curved lines, and mark where they intersect.

4 Use a triangle or ruler to draw lines from each point to establish your three-point perspective.

ESTABLISH THE STATION POINT

5 Use the distance between VP1 and VP4 to find the station point on the vertical (red dotted) line down to VP3. This will be the point to set up as many sets of vanishing points as are required, as long as the angle at the station point is 90°.

6 An equilateral triangle works either above or below the horizon line, so it can be used for a composition that will be viewed either from above (bird's eye) or from below (worm's eye).

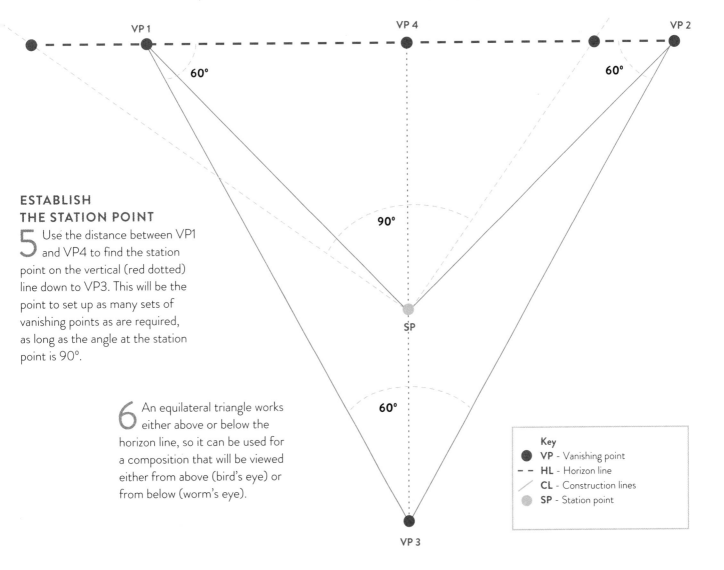

Key
- **VP** - Vanishing point
- **HL** - Horizon line
- **CL** - Construction lines
- **SP** - Station point

LOCATING THE VANISHING POINTS

When locating vanishing points in a three-point perspective view of an object or structure, two are along the horizon line, just as in two-point perspective, but the third is located either above or below the horizon line, depending on the area you intend to draw.

In order to locate the third vanishing point, look at the angles that define the edges of the structure or objects, and follow them until they intersect and converge with one another.

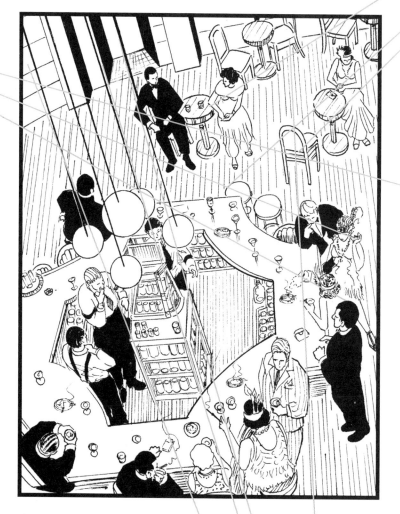

VP 2

VP 1

▲ When locating the vanishing point, take the reverse engineering approach. Follow the angles of any object with a ruler, take a piece of tracing paper and overlay onto the page, then draw construction lines to find all three vanishing points.

HINT: This composition is tilted and your horizon line is high above the panel.

VP 3
↓

Key
● **VP** - Vanishing point
- - **HL** - Horizon line
/ **CL** - Construction lines

PRACTICE HERE

Find the vanishing points to each object by using a ruler or triangle along the receding sides. Draw a line until they converge.

Once you uncover the vanishing points, draw some of your own shapes within the equilateral triangle for practice.

DRAWING ONE 3-D BOX

In this exercise, the construction of the box is below the horizon line, which separates everything above the viewer's eye level from everything below. The 3-D box will get smaller in the distance toward a vanishing point on the left or right. You'll notice the distortion of the cube in the example depicted because of its placement; the closer to the vanishing points the planes of the cube are, the more distortion will occur.

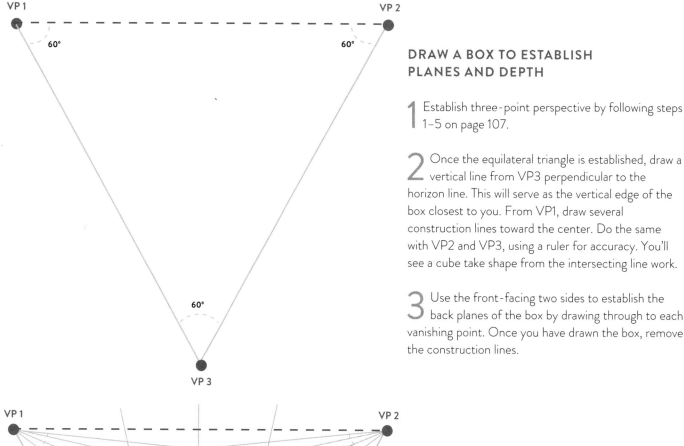

DRAW A BOX TO ESTABLISH PLANES AND DEPTH

1 Establish three-point perspective by following steps 1–5 on page 107.

2 Once the equilateral triangle is established, draw a vertical line from VP3 perpendicular to the horizon line. This will serve as the vertical edge of the box closest to you. From VP1, draw several construction lines toward the center. Do the same with VP2 and VP3, using a ruler for accuracy. You'll see a cube take shape from the intersecting line work.

3 Use the front-facing two sides to establish the back planes of the box by drawing through to each vanishing point. Once you have drawn the box, remove the construction lines.

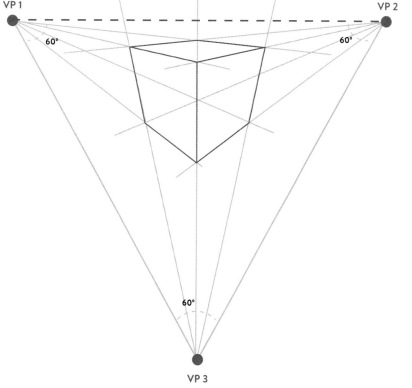

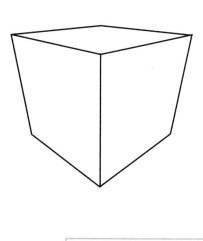

Key
● **VP** - Vanishing point
- - **HL** - Horizon line
╱ **CL** - Construction lines

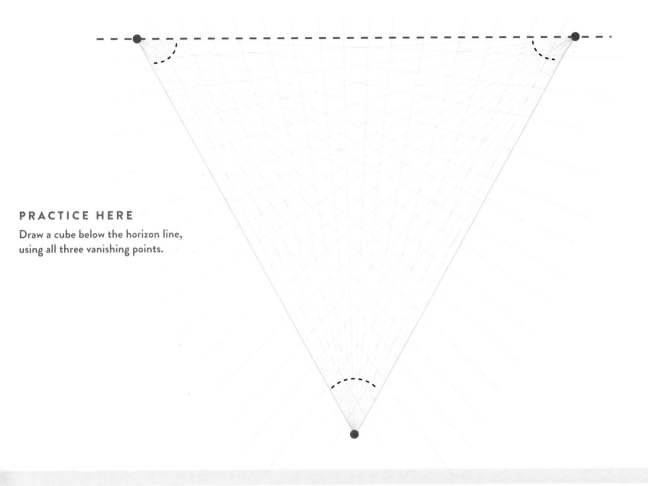

PRACTICE HERE
Draw a cube below the horizon line,
using all three vanishing points.

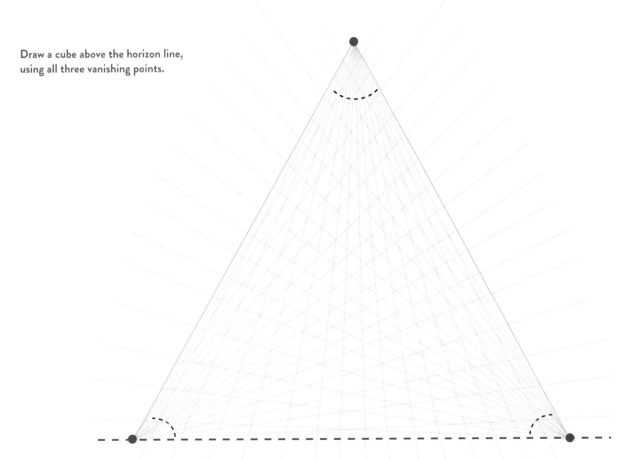

Draw a cube above the horizon line,
using all three vanishing points.

DRAWING MULTIPLE 3-D BOXES

Once you understand how to draw one object in three-point perspective, you can apply the same principles to drawing multiple objects in the same scene. The important thing to remember is that each object has its own set of vanishing points, so you need to look at each one in turn.

Here we are working with a high viewpoint—a bird's-eye view. Start by establishing the station point by following steps 1–5 on page 107. It is from this point that you will plot the vanishing points of every object in the scene.

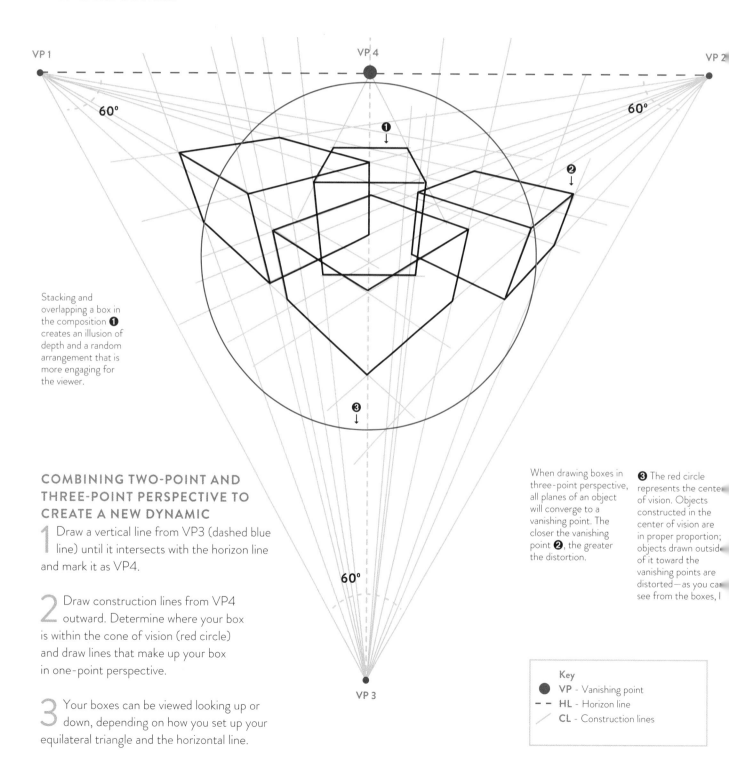

Stacking and overlapping a box in the composition ❶ creates an illusion of depth and a random arrangement that is more engaging for the viewer.

COMBINING TWO-POINT AND THREE-POINT PERSPECTIVE TO CREATE A NEW DYNAMIC

1 Draw a vertical line from VP3 (dashed blue line) until it intersects with the horizon line and mark it as VP4.

2 Draw construction lines from VP4 outward. Determine where your box is within the cone of vision (red circle) and draw lines that make up your box in one-point perspective.

3 Your boxes can be viewed looking up or down, depending on how you set up your equilateral triangle and the horizontal line.

When drawing boxes in three-point perspective, all planes of an object will converge to a vanishing point. The closer the vanishing point ❷, the greater the distortion.

❸ The red circle represents the center of vision. Objects constructed in the center of vision are in proper proportion; objects drawn outside of it toward the vanishing points are distorted—as you can see from the boxes, l

Key
- ● **VP** – Vanishing point
- – – **HL** – Horizon line
- / **CL** – Construction lines

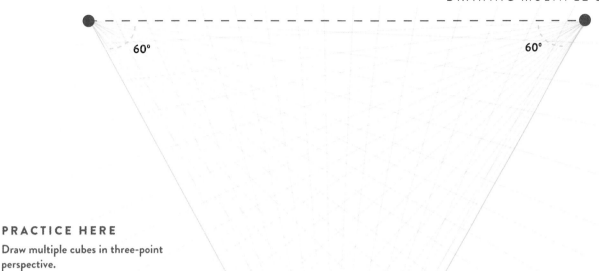

60° 60°

60°

PRACTICE HERE

Draw multiple cubes in three-point perspective.

Establish three-point perspective for cubes below the horizon line. You may add a vanishing point perpendicular to the horizon line to VP3, creating a two-point vertical that works in tandem. The viewer is either looking up or down at objects in two-point vertical perspective, but only one VP can originate on the horizon line.

DRAW A SCENE

Establish three-point perspective. The vanishing points should lie outside the page to allow room for an interior or exterior location that could serve as a scene in your story.

Using artist's tape, attach three sheets of letter-size paper to each side of the page so that you have space to plot your vanishing points.

DRAWING A HUMAN FIGURE

In comic books, it is less common for figures to be drawn in three-point perspective than in two-point because of the unusual angle—looking up or down at the subject. However, drawing a figure in three-point perspective can expand your drawing and storytelling capabilities. For example, a bird's-eye view provides an overview of a scene, so the placement of the characters and what they're doing can be visually engaging for a reader.

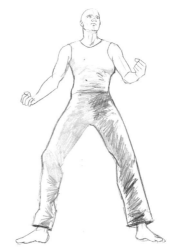

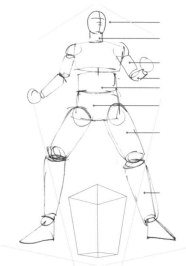

▲ The worm's-eye view, looking up at a figure from a low angle, can empower a character and compound the action into a visually dramatic piece of storytelling.

▲ The key to any of these angles is understanding how to visually measure the height of a figure and use that as a reference point for all other characters and objects occupying that picture plane in three-point perspective.

Using an equilateral triangle to establish your three-point perspective layout, lightly sketch in a rectangular shape, like a column.

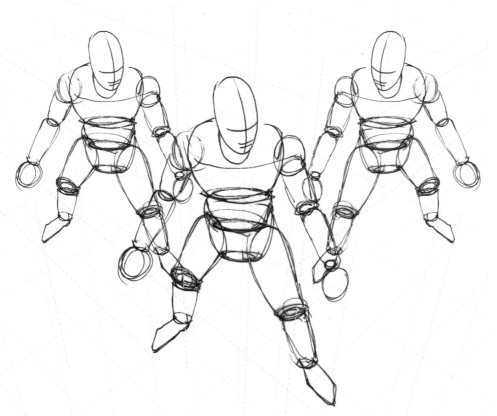

▼ Establish a standard scale of measurement. A figure at eye level is seven "heads" tall. Simplify your figure into spherical and cylindrical shapes.

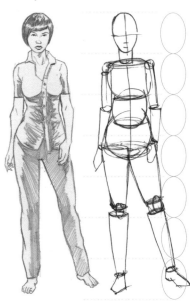

▲ It's important to understand that the proportions of the figure may appear larger or smaller, depending on your viewpoint. The lowest vanishing point will help keep the figure in perspective. If you are looking down, the figure will be wider at the the top (the head), with the body tapering to smaller proportions as the construction lines converge down to a vanishing point. If you are looking up, the figure will be wider at the base (the feet) than at the head.

Before adding in details that make up a human figure, be sure to check your basic shapes, as above.

PRACTICE HERE

▶ Simplify the figure by drawing over it using cylindrical and spherical shapes. Your simplified drawing should look like the figure on the right.

Now, embellish the simplified figure as a male or female and draw a costume, providing details that bring the character to life—a spaceship pilot, steam-punk adventurer, or whatever your imagination dreams up.

▼ Draw as many human figures in the three-point perspective grid using only basic shapes. Feel free to draw in a variety of poses. Note how the smaller figure is in proportion with the foreground figure on the horizon line. Her head does not go beyond the construction line of the foreground figure as it converges to the vanishing point.

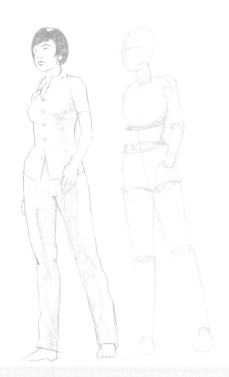

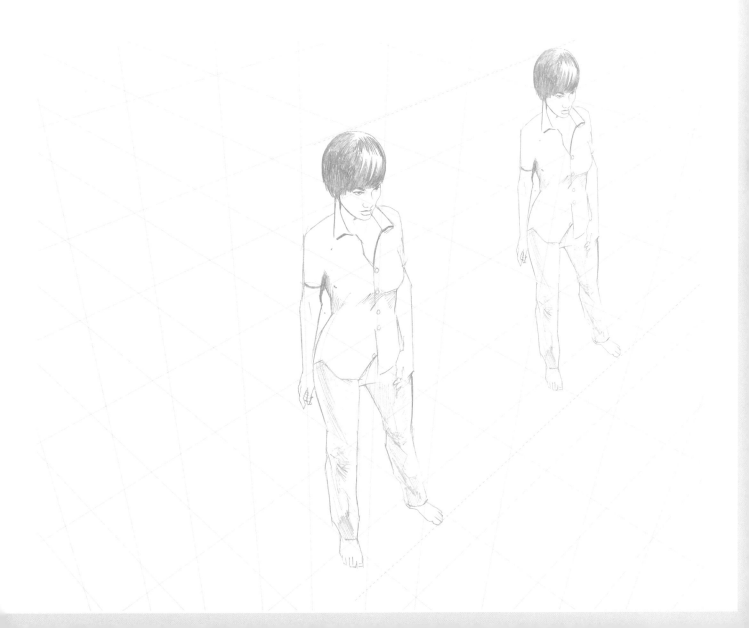

DRAWING A HUMAN FACE

The same principle of drawing figures applies to drawing faces in three-point perspective. Approach every subject and object in your composition as basic shapes constructed by the vanishing points.

▲ Regardless of your viewpoint, or whether you are drawing a male or a female head, the underlying head construction is the same. The proportions of a head will vary from person to person and change slightly with age.

1 Establish your three-point perspective (looking up or down). Then, using light, loose, quick gesture lines, sketch out an oblong shape. To set up the features of the head, find the center of each plane by drawing diagonal lines to the corners of each, creating an "X" (see pages 34–35).

2 The oblong shape helps establish proper perspective within the construction lines to the vanishing points. Draw horizontal and vertical lines to subdivide the head into quarters. Place the eye sockets between the two horizon lines. The corners of the eyes line up with the nostrils of the nose. The ears fall between the eyes and either the nostrils or the tip of the nose. Sketch vertical lines that create the corners of the mouth.

3 Sketch in details, such as the eyebrows and hair, go over contour line weights, and clean up the construction lines.

As you practice drawing heads in three-point perspective, try to exaggerate some of the features and facial expressions to improve your drawing mechanics, demonstrating a range of emotions in your characters.

Draw male and female heads of different ages, ethnicities, and hairstyles to explore the range of characters you can achieve.

PRACTICE HERE

▶ Draw your own characters over these heads as male or female, robot or alien creature. These blue-line structural sketches are meant to help you improve your ability to draw the head in proportion.

▼ Draw one male or female head in three-point perspective, one looking down (left grid) and one looking up (right grid). Follow the steps from the opposite page, and be sure to check the proportions of the face before adding details.

SPACING REPEATING OBJECTS

Because three-point perspective visualizes extreme height or depth, not only do you have to consider the width of objects and the width of the space between the objects going across, you must also determine the width of objects and the space between them going up or down.

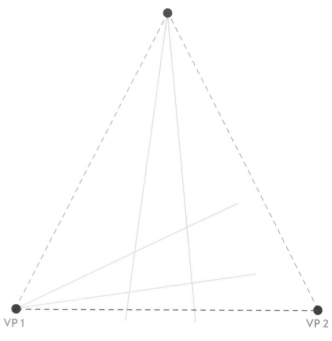

1 Draw an equilateral triangle. Using VP1, draw two construction lines to establish the height of your window. Using VP3 draw another two construction lines down to the HL to determine the width of your window.

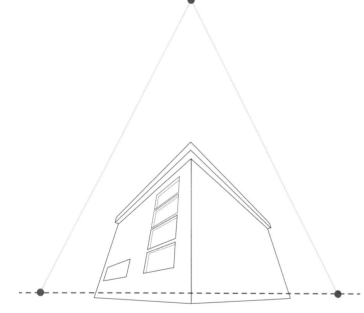

DRAWING WINDOWS LOOKING UP

Working out the space between repeated objects, such as the windows shown here, can be done using the basic principles of perspective—just remember to plot lines converging at this third vanishing point way above the building, as well as to the vanishing points that lie off to each side.

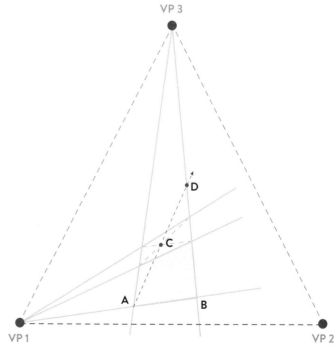

4 Find the next window by drawing a construction line from the corner of A through the middle of space C until it intersects with the construction line at point D, going to VP3.

Key
● **VP** - Vanishing point
-- **HL** - Horizon line
╱ **CL** - Construction lines

2 Above that shape, draw another construction line from VP1. This will determine the space between the windows.

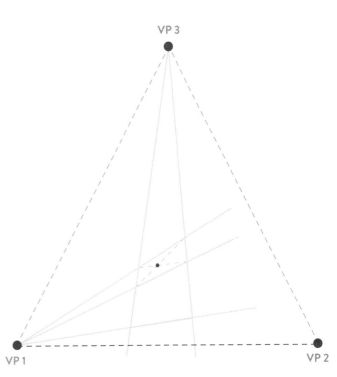

3 Find the middle of the space between the windows by drawing diagonal lines inside the shape from corner to corner.

5 Draw a construction line from point D back to VP1—this is your next window going up. To add more windows, draw a construction line through the intersecting point in space C, up to VP3.

6 Draw a new construction line from E to F, through the intersecting point up to VP3. From the new point F, draw a construction line back to VP1. This is the new space before you repeat steps 4–5 to create the next window.

SPACING REPEATING OBJECTS CONTINUED

Key
- **VP** - Vanishing point
- - **HL** - Horizon line
- **CL** - Construction lines

The same principle used to establish repeating objects going up (or down) applies to determining repeating objects going across.

1 Draw your window using VP1 to establish the height and VP3 for the width. Draw the space between windows and, using VP3 for its width, make sure it falls between the two construction lines to VP1.

2 Find the center of the window by drawing diagonal lines from corner to corner. Once established, draw a construction line from the center to VP1.

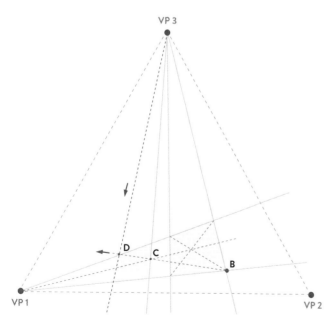

3 Draw a diagonal construction line from the bottom corner of the first window (B) through the point where the construction line created in step 2 intersects construction line C. Where that line hits the top construction line to VP1 is D—you have now defined the width of the second window.

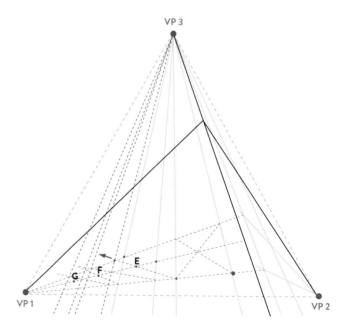

4 From that point on, repeat steps 1–3 to find the center of more windows (E to G). From there, just continue on and repeat the steps to draw windows to VP1 (or VP2 for another wall of windows).

PRACTICE HERE

Draw a building in three-point
perspective that has windows and
columns from a low-angle viewpoint.

PLACING THE CAMERA: MID-LEVEL VIEWPOINT

Drawing three-point perspective at eye level can be tricky, because it's usually used for scenes looking up or down in comic books. However, just as in two-point perspective, your horizon line is determined by the character's point of view (POV).

At first glance, each of these scenes could be rendered as two-point perspective, but a closer examination reveals that vertical lines all converge beyond the comic panel.

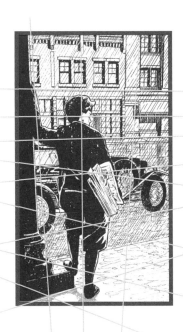

◄► FOCAL POINT
Each of these two examples demonstrates how all the vanishing points originate beyond the panel borders (red), with the exception of the one-point VP on the horizon line. You can do this by establishing a fourth VP perpendicular from the horizon line to VP3.

Whatever the subject, always lead the reader's eye to the focal point by using angles, movement, shapes, light, and shadow in the composition.

▲► The Dutch tilt is a cinematic tactic often used to portray psychological uneasiness or tension in the subject matter. It is achieved by tilting the camera off to the side so that the shot is composed with the horizon at an angle to the bottom of the panel.

Key
● **VP** - Vanishing point
- - **HL** - Horizon line
╱ **CL** - Construction lines

PRACTICE HERE

Draw a scene with a person in
the foreground entering a room.
The horizon line will be at the
character's eye level. This could
be your own room, a make-believe
one, a scene from your comic book,
or whatever you want it to be—but
make it look awesome!

PLACING THE CAMERA: LOW-LEVEL VIEWPOINT

A low-level viewpoint, where you're looking up at the subject, can be a great way of creating a feeling of fear and foreboding in your comic-book panels. Whether you're drawing Batman about to wreak vengeance on the villains, a spaceship full of invading aliens, or a castle inhabited by an evil monster, this low-level viewpoint shows the character or object looming over us.

It's sometimes hard to tell the difference between two- and three-point perspective. For example, if you were to kneel down on a street corner with cars going by and tall buildings in the background, the vertical lines of the buildings would converge to a third vanishing point high in the sky. The cars, however, would be much closer to your eye level and might appear to be in two-point perspective, but they too would go to a third vanishing point in the sky, because their roofs would be above your eye level. Be aware of this when you're drawing: things don't always need to be extreme and exaggerated to be in three-point perspective.

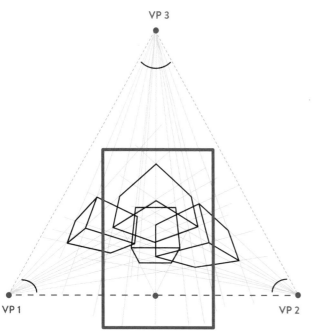

Key
● **VP** - Vanishing point
– – **HL** - Horizon line
╱ **CL** - Construction lines

◀ To find the vanishing point in any drawing, simply use a sheet of tracing paper or vellum—take a ruler, and trace the angles of the objects until they all intersect at a point.

▲ A castle is established in this scene with a character springing toward the door. Since we're looking up, the third vanishing point is above the panel while the other two are located on the horizon line outside the panel as well.

▶ The low-angle view depicted here puts the reader up close to the action, as if they're seated on the floor next to the character at his desk.

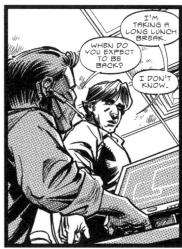

PRACTICE HERE

Draw the following worm's-eye view scene.

A man and a woman have their backs to us and are standing in a city looking up at the sky. The normal city we saw at the beginning of the story has completely transformed into a futuristic city of tomorrow. We see towering spires, flying cars, people in clothing styles of 400 years from now, and, in the distant sky, a tiny caped figure flying over the newly morphed city. Although he is small, we can see that his hands are glowing!

PLACING THE CAMERA: HIGH-LEVEL VIEWPOINT

The bird's-eye point of view in three-point perspective can produce an array of dynamic visuals, giving exaggerated views of the subject and an emphasis on height or depth.

When you compose your scenes with this point of view in mind, consider how it will impact your viewer and how it will impact the scene.

The bird's-eye view can tend to make subjects small and unrecognizable—so if you're looking to show your characters up close with detail, this is not the viewpoint to choose.

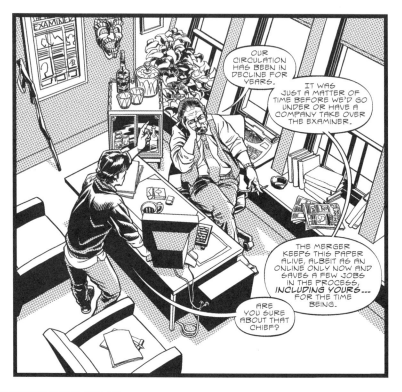

▲ This angle can make a character look vulnerable, as the figure standing over the desk imposes his will by questioning his employer's statement. Note the body language of each character.

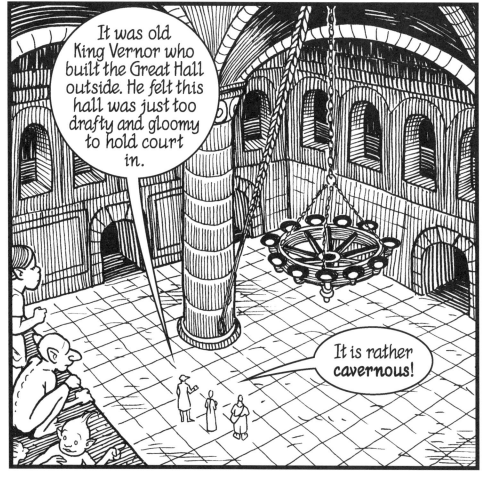

◄ Comic book artist Linda Medley uses high-angle shots to engage the reader with dynamic visuals. Note the characters in the foreground as they look upon the figures down below. Their bold lines create depth whereas the line work of the figures on the ground is thinner and softer since they're farther away from the reader.

PRACTICE HERE

Draw a bird's-eye view of fantasy warriors, such as a swordsman, a wizard, and an elf with a bow and arrow, all with their backs to one another in a circle fighting off a bunch of giant spiders in a garden. This angle should be high enough to show only the spiders and warriors, like a camera positioned on a light fixture hanging from the ceiling.

DRAWING EVERYDAY OBJECTS

With all their planes, curves, and angles, cars can be complicated things to draw—but they won't look right unless you use perspective.

Usually your point of view of a motorized vehicle, such as a car or a truck, is in two-point perspective from your eye level. In three-point perspective, your car will be seen from an elevated point of view looking down, or from a low angle looking up.

For this exercise, establish your three-point perspective. Whether you work from reference or draw a vehicle from your imagination, keep in mind that cars (real or imagined) are symmetrical.

2 Clean up your drawing and start embellishing some of the contour lines that will define the shape of the car.
HINT: Use tracing paper over your sketch if you have too many construction lines to draw your car. This way you can embellish only the contour lines that make up your car.

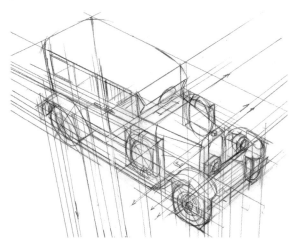

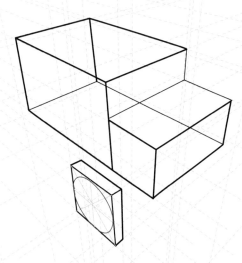

1 Start to block out the shape of the car from end to end, top to bottom, using simple boxes and shapes. When drawing a wheel, go back to page 34 on drawing an ellipse for the correct proportions in relation to the automobile.
HINT: Use your construction lines just as you would for drawing shapes receding to the vanishing point. Note the wheels line up between the construction lines to the VP.

3 You've established your construction lines, drawn the basic shape of your vehicle, and drawn the characteristics that define it. Use an eraser to remove some of the construction lines to embellish the contour lines, add shadows for contrast, and draw details for a finished look to your image.

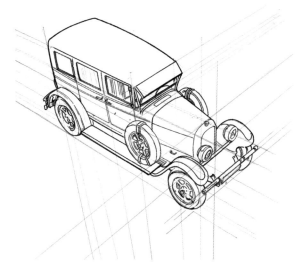

PRACTICE HERE

Trace over the automobile and embellish the contour lines, add details, and illustrate as something you might see in a comic book.

Use the three-point perspective grid to draw your own car, truck, or vehicle. You may also draw the car pictured here.

HINT: Take a photograph from an elevated point of view looking down at a car from an upstairs window.

LITTLE SCENES

When using perspective to tell a story in comic books, think of the impact it has on the scene. Does it add to it? In the case of three-point perspective, you are either looking up or down at a scene.

◣ The bird's-eye view shot of the hospital room provides the reader with an overview of the characters in this scene. You can introduce a scene this way, allowing space for word balloons and captions as a segue into the next eye-level panel of the two characters talking. Note the high contrast created by the light source from the lamp and window, which adds emotion to the situation.

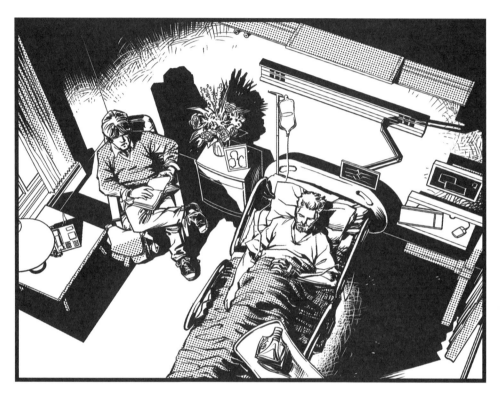

▽ This science-fiction scene is from the point of view just below the horizon line. You'll notice a bit of atmospheric perspective in the background: there is less contrast, fewer contour line weights, thinner lines, softer shapes, and an overall impression of shapes and forms. The foreground has contrast, details, variety of line weights, and sharper images. Atmospheric perspective in line drawings creates an illusion of depth and makes the figures "pop out" of their comic panel, bringing them into sharper focus.

▲ This building is an establishing shot for a new scene. The three-point perspective gives the reader the entire scope of the setting. The low-angle, worm's-eye view allows the reader to look up and see the nighttime sky. The location and time of day are established from this angle.

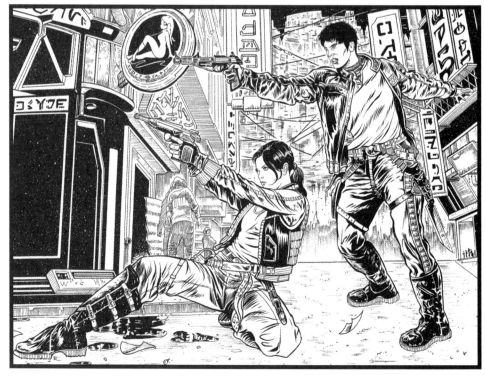

PRACTICE HERE

MID-LEVEL VIEWPOINT (inset panel): A teenage boy or girl turns around, their back toward the viewer, and we see past the back of their head to the corner of the building behind them— smoke wafting into the air. . . and a creepy, small T-Rex hand reaches from behind the building through the smoke!

WORM'S-EYE VIEW (middle): A T-Rex roars from behind the building and menaces the teenager. People are running toward the reader (and the teen), getting out of their cars and delivery trucks. One is riding a moped between vehicles. All heck breaks loose!

BIRD'S-EYE VIEW (lower panel): A woman helps the teenager by pulling the boy or girl into a manhole that utility workers abandoned as the T-Rex rampaged toward them. Keep in mind that the reader should recognize the downtown city setting by the objects and structures that make up the scene. Imagine traffic lights, mailboxes, trash cans, newspaper stands, hot dog/ coffee carts, people, cars, trucks, etc.

DRAW AND FILL-IN

You've been introduced to the drawing principles
of three-point perspective for creating objects from
various angles, such as drawing a car, a human
figure and face, and dividing up spaces for vertical
structures. So let's apply some of that knowledge
to the unfinished drawing below.

Find the vanishing points for a worm's-eye view
scene and add details (windows, billboards, new
buildings, a plane, helicopter, or blimp,
automobiles, trucks, etc). In the foreground,
draw two superbeings battling it out in the sky!

PRACTICE HERE

Create a line drawing of a street looking down from a high angle.

This scene can be during any time in human history, anywhere in the world, but it cannot be a make-believe place. Here are the guidelines:

Apply parallel lines to keep sizes consistent—if a figure fits between two construction lines that converge on the horizon, then the figure will fit between them at any point on that path.

Include automobiles, windows, steps, doors, furniture, and gates that relate to figures proportionally and to scale with one another.

Apply the figure as a measure to project the height receding to the background.

PRACTICE HERE

Draw three realistic figures using three-point perspective. Create a figure sitting in a chair or on a couch, at a café, or in a restaurant; a few figures walking in different directions (toward the viewer, away from the viewer, side to side); and a figure standing by a doorway or window drinking.

The characters should be a variety of ages and body types. Draw your figures in natural poses. Use reference if necessary.

PRACTICE HERE

Create a worm's-eye view scene of a
monster attacking a major city.
The monster can be a giant insect,
mammal, reptile, or one from your
imagination. Use iconic structures
that are easily recognizable, such as
Tower Bridge in London or the Empire
State Building in New York City.

PRACTICE HERE

Draw an aerial shot of a wedding
taking place in front of a castle by
a winding river.

PRACTICE HERE

Draw a low-angle scene of a group of heroic characters charging toward the reader. The scene can be inside (cavernous industrial complex, alien spaceship, high school gymnasium) or outside (jungle, city street, or observatory).

COMIC BOOK
CRASH COURSE
AND
WORKBOOK

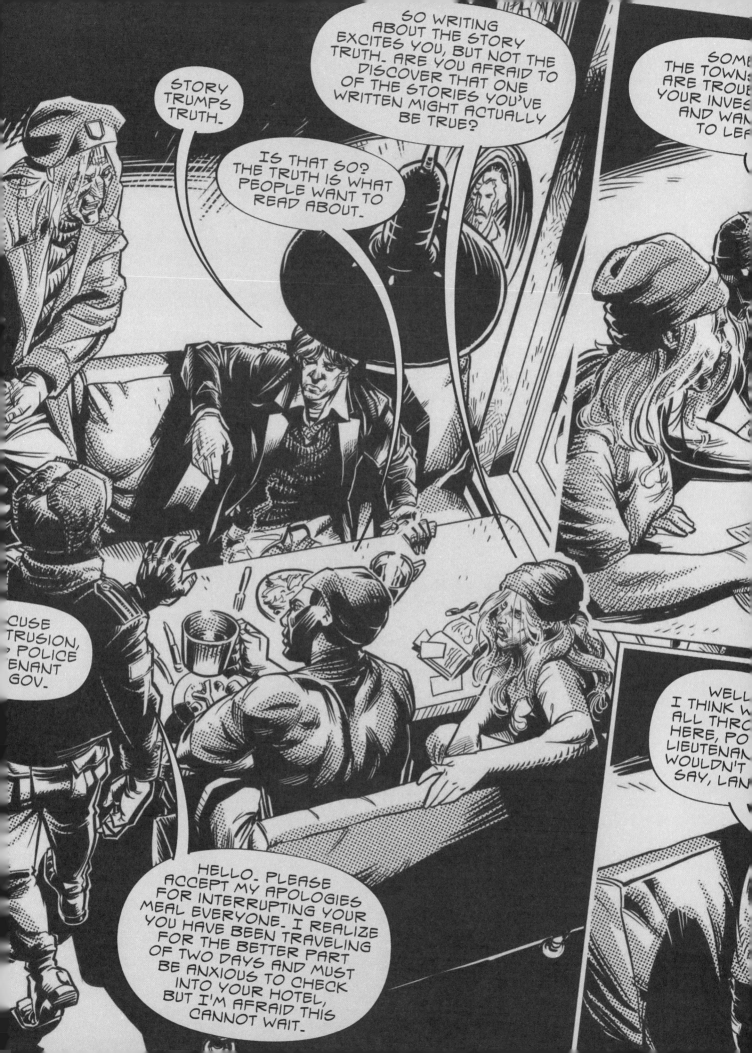

USING PERSPECTIVE FOR DYNAMIC STORYTELLING

No matter what type of perspective you use, you should create dynamic layouts with the emphasis on leading the reader's eye through the panel and page.

The actual size of the frame in relation to its content is an important consideration. The size of a panel, along with the size and focus of its content, contributes to the emotional impact on the reader.

MAKE IT INTERESTING

In today's ever-changing and competitive market, an artist won't get very far without discipline and imagination. A panel may be drawn with every component painstakingly correct, yet still be uninteresting to the reader. If the artwork is uninteresting, the artist is not doing their job.

When composing the panel, don't just pencil the subject. Think about what you can include to make him, her, or it more interesting. Add some action or a different viewpoint.

CHANGING PERSPECTIVES: LEADING THE READER THROUGH SPACE

As a reader moves through the pages of a story, they should be able to follow the action clearly. The Batman page, below, illustrated by Chris Marrinan, is a good example of how the artist leads the reader's eye through the action.

Vanishing point

Focal point

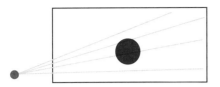

PANEL 1 An upshot of Batman centered in the panel is the focal point for this sequence. Note how the radiating lines and Batman's cape suggest the downward direction of the reader's eye—a visual subtext for telling the eye where to move.

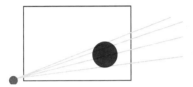

PANEL 2 The bullet lines penetrate the glass doors as Batman bursts out. Again, the lines of the bullets and his cape have the direction moving from left to right, as opposed to downward in the previous panel.

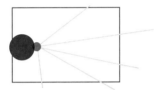

PANEL 3 The reader's eye is drawn to Batman in the foreground. The heavy black inkwork draws your eye in, as the police car on the right frames the officers in the background. The radiating police lights help draw attention to the officers as well.

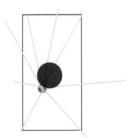

PANEL 4 A low-angle upshot from the reader's point of view hones in on Batman as he leaps on top of the police car, firing off a grappling hook from his wrist into the air. The vanishing point falls behind Batman as the lines of the buildings converge, drawing the reader's attention to the center of the panel.

PANEL 5 A dynamic downshot of Batman as he lunges into the air. The foreshortened leg, which comes toward the reader, is the focal point. Good visual narrative using well-composed panels is enhanced by the contrast of light and shadow, line weights, and body language.

▲ DUTCH TILT
This panel alters a familiar perspective to create speed and intensity as the car races down a deserted highway, evading police. Observe how the entire panel and all of its elements are drawn at an angle to emphasize the direction of the car speeding toward the reader.

▲ FLAT AND UNINTERESTING
Nothing wrong with this, but it's a bit flat and a bit unclear as to what is happening: what are those big black things on the left? Why is the man in the truck looking back? Never assume your reader can interpret what you "suggest" visually. Give them a panel composed with clarity, leaving no doubt as to what the action is.

▲ DYNAMIC AND EXCITING
A three-quarter view reveals what's happening. The car is evading the police as a pipe breaks away from the truck. This increases the sense of danger and compounds the action of the getaway car. Always compose more than one composition per panel from various angles to figure out which one best serves the story.

CAMERA SHOTS AND ANGLES

▼ CLOSE-UP

Graphic novels succeed because their pictures give visual clarity to the reader, which is supported by a sound story structure. One way of ensuring that your figures are dynamic is to use a variety of camera shots and angles.

ESTABLISHING SHOT

This is a mandatory shot that is essential for establishing the setting of the story. The establishing shot can be used for any location, just as long as you give enough visual information for the reader to grasp where the action occurs. Usually, a rule of thumb would be to use an establishing shot for every scene change, each time a new element is introduced in the scene, or when a character moves through a scene.

POINT OF VIEW

The point of view shot has the reader looking through the eyes of a specific character.

OVER-THE-SHOULDER SHOT

This is a shot of someone or something taken over the shoulder of another person. The back of the shoulder and head of this person is used to frame the image of whatever (or whomever) the camera is pointing toward. This type of shot is very common when two characters are having a discussion, and will usually follow an establishing shot that helps the reader place the characters in their setting.

HIGH-ANGLE SHOT

Also known as the bird's-eye shot, the camera looks downward, generally from just above head height. This angle can make a subject look vulnerable.

LOW-ANGLE SHOT

Also known as the worm's-eye shot, the camera looks upward toward a subject, and can make the subject look powerful.

CLOSE-UP

A panel that emphasizes the subject and can include a facial expression, with or without hand gestures.

MEDIUM SHOT

A panel featuring the subject from the waist up—with a background that may be very detailed or not detailed at all.

LONG SHOT OR FULL SHOT

Imagine a figure illustrated in full from head to toe—with an emphasis on the background the character occupies. Distance is key here, with the camera far enough away to show the location and who is involved in the scene.

▲ LOW-ANGLE SHOT

▲ POINT OF VIEW SHOT

◀ HIGH-ANGLE SHOT

▲ FULL SHOT

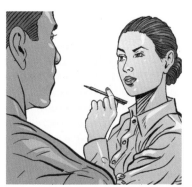

▲ OVER-THE-SHOULDER SHOT

▲ MEDIUM SHOT

▲ ESTABLISHING SHOT

PUTTING IT ALL TOGETHER

WORKING FROM A SCRIPT

Keep it simple and clear, but in an engaging way—if it isn't in the script, do not overdraw by penciling in unnecessary objects and details. In each and every panel, clarity is your priority in order for characters, objects, and backgrounds to work together.

▼ BLUELINE PENCIL

It is common for some comic artists to use a blueline "non-photo" blue pencil for their underdrawings on comic pages, which is what artist Jeff Himes has demonstrated here. This allows the artist to sketch freely to search for the best composition before inking.

▼ ESTABLISHING SHOT

Every scene should have a clear establishing shot of the setting for the characters to play through, whether they walk through the scene or not. A visual tag in this scene is the black winter coat. The focus in each panel is the main character, Lane.

▲ STORYTELLING AND LAYOUT
The landscape page layouts are a tip of the hat to the golden age of Sunday newspaper strips, with their serialized storytelling. The format also works well on a computer screen or portable reading device and offers up something different for the reader.

The apple, first introduced in panel 2, is a visual tag that carries through the scene. This storytelling device helps the reader track the main character, as the camera work changes from panel to panel.

DRAW A LINE DRAWING OF A STREET IN ONE-POINT PERSPECTIVE

Apply parallel lines to keep sizes consistent. If a figure fits between two construction lines that converge on the horizon, then the figure will fit between them at any point on that path.

DRAW THREE REALISTIC FIGURES IN TWO-POINT PERSPECTIVE

Draw a figure sitting on a park bench, another figure walking their dog, and one standing by a drinking fountain.

DRAW A COMPLETE LINE DRAWING OF AN INTERIOR SCENE IN TWO-POINT PERSPECTIVE

Draw from any angle: bird's eye, worm's eye, or eye level.

DRAW A WORM'S-EYE VIEW OF A MONSTER ATTACKING A MAJOR CITY IN TWO-POINT PERSPECTIVE

Draw civilians running away in terror as the monster—drawn from your imagination—destroys buildings, cars, and anything standing in its way.

DRAW A BIRD'S-EYE VIEW OF TWO SUPERHEROES IN TWO-POINT PERSPECTIVE

Spider-Man vs. Superman, for example, in combat over a major city.

DRAW A SCENE AT EYE LEVEL FROM ONE OF YOUR FAVORITE FILMS OR BOOKS IN TWO-POINT PERSPECTIVE

Use all the details necessary to make it easily recognizable for the viewer.

DRAW FIGURES IN COMBAT IN THREE-POINT PERSPECTIVE

Your drawing must demonstrate two figures in hand-to-hand combat; punching, kicking, and wrestling are encouraged, but no guns or remote weapons should be involved for this exercise. Poses should feel authentic and have movement. Use reference if necessary. Think about how the background becomes an environment that reflects the nature of the characters.

Take time to draw the anatomy, proportion, and foreshortening of various body parts as accurately as you can.

DRAW A SCENE FROM ANY ANGLE OF A DYSTOPIAN FUTURE IN ONE-POINT PERSPECTIVE

Draw custom cars, trucks, and commercial vehicles chasing an automobile through the desert—think Mad Max.

DRAW A CIRCUS SCENE UNDER THE BIG TOP IN THREE-POINT PERSPECTIVE

The point of view should be that of a spectator in the stands watching the show. Imagine clown cars, trapeze acts, monkeys, bears on unicycles, a man being shot out of a cannon—the possibilities for a fun scene are endless.

DRAW A FUTURISTIC CITY ON AN IMAGINATIVE PLANET IN THREE-POINT PERSPECTIVE

Create a scene with flying spacecrafts, floating advertisements in the air, and pedestrian bridges connecting to various buildings. This scene can be from any angle, such as a character's point of view, or an over-the-shoulder shot of a busy marketplace. Treat each scene you draw as if you're telling a story.

GLOSSARY

ACTION The visual movement of the figure within the panel.

ANGLE SHOT A composition within the panel from a different point of view, or a different angle of the action from the previous panel.

ANTAGONIST The principal character in opposition to the hero of a narrative.

BACKGROUND The general scene or surface against which characters, objects, or action are represented in a panel.

BIRD'S-EYE VIEW A point of view elevated above an object, as though the reader were a bird looking down at the action of the panel.

BLEED Art is allowed to run to the edge of each page, rather than having a white border around it. Bleeds are sometimes used on internal panels to create the illusion of space or to emphasize action.

CAMERA ANGLE The angle of the point of view from the reader's perspective. The camera angle can greatly influence the reader's interpretation of what is happening on the comic book page.

CAPTIONS Comic book captions are a narrative device, often used to convey information that cannot be communicated by the art or speech. Captions can be used in place of thought bubbles; they can be in the first, second, or third person, and can either be assigned to an independent narrator or to one of the characters.

CENTER OF VISION The focal point of an area upon which the person's eyes are fixed at the end of the line of sight.

CLOSE-UP (CU) A shot or composition that concentrates on a relatively small object, human face, or action. It puts the emphasis on emotion to create tension.

COMPOSITION The arrangement of the physical elements (or the subject matter) within a comic book panel. A successful composition draws in the reader and directs their eye across the panel, so that everything is taken in.

CONE OF VISION The area of a person's vision in which their eyes see what is undistorted—a natural 60-degree angle that extends as an imaginary cone. Outside of the 60-degree angle, objects begin to blur.

DIAGONAL LINES Receding parallel lines (or rows of objects) converging to the vanishing point. These imaginary lines serve as guides that enable artists to construct perspective in their drawings in order to simulate a realistic view of the object. Diagonal lines are used to create the illusion of three-dimensional objects in a two-dimensional medium.

DIALOG Conversation between characters in a narrative.

DOUBLE-PAGE SPREAD Two comic book pages designed as one large page layout.

DUTCH TILT A shot in which the camera is set at an angle, so that vertical lines are at an angle to the side of the frame, or that the horizon line is not parallel with the bottom of the frame.

ESTABLISHING SHOT A shot that sets up the context for a scene by showing the relationship between its important figures and objects.

EXTERIOR (EXT) A scene that takes place outside any architectural structure.

EXTREME CLOSE-UP (ECU) A subject or action in a panel that is so up close that it fills the entire panel.

EXTREME LONG SHOT (ELS) A shot that typically shows the entire human figure in some relation to its surroundings.

EYE MOVEMENT The arrangement of words and pictures in the panel, directing the narrative eye of the reader throughout the page layout.

FIELD OF VIEW The field of view (or FOV) determines how much we can see by how close or how far apart the vanishing points are on the horizon line.

FLASHBACK An interjected scene comprised of panels that takes the narrative back in time from the current point of the story. Flashbacks are often used to recount events that happened before the story's primary sequence of events or to fill in crucial backstory. Character-origin flashbacks are flashbacks that deal with key events early in a character's development.

FOCAL POINT The emphasis of action, subject, or any element in a panel.

FOREGROUND (FG) Objects, characters, or action closest to the reader in a panel.

FULL SHOT (FS) A composition comprised of an individual, a group, or the center of the action in a single panel or page that illustrates the entire subject.

GRAPHIC NOVEL A narrative work in which the story is conveyed to the reader using sequential art in either an experimental design or in a traditional comics format. The term is employed in a broad manner, encompassing non-fiction works and thematically linked short stories, as well as fictional stories across a number of genres.

GRID A series of panels organized on a page, often consistent in size and shape, for visual storytelling. The artwork is traditionally composed within each panel, separated by the equal spacing of gutters.

GUTTER The space between two panels within a comic strip or book.

HIGH-ANGLE SHOT Also known as a bird's-eye shot, the camera looks downward, generally from just above head height. This angle can make a subject look vulnerable.

HORIZON LINE This represents the height from which you are viewing the object or scene. Outdoors, this will actually be the horizon; indoors, it will be a line that represents your eye level. The only exception would be if you were outside, viewing from a very high or wide vantage point, in which case the slight curvature of the earth would be noticeable.

INKER The inker (also sometimes credited as the finisher or the embellisher) is one of the two line artists in a traditional comic book or graphic novel. After a penciled drawing is given to the inker, the inker uses black ink (usually India ink) to produce refined outlines over the pencil lines.

INSET PANEL A panel within a larger panel, often used as a close-up on the action to evoke emotion or to drive the narrative.

INTERIOR (INT) A setting that takes place inside a structure such as a house, office building, spaceship, or cave.

LETTERING The art of lettering is penned from the comic book creator responsible for drawing the comic book's text. The letterer crafts the comic's "display lettering"—the story title lettering and other special captions

credits that usually appear on a story's first page. The letterer also writes the letters in the word balloons and draws in sound effects. The letterer's use of typefaces, calligraphy, letter size, and layout all contribute to the impact of the comic.

LINE OF SIGHT A term that applies to an imaginary trajectory from a person's eyes straight on to the subject.

LONG SHOT (LS) A shot that typically shows the entire human figure and is intended to place it in some relation to its surroundings.

LOW-ANGLE SHOT Also known as a worm's-eye shot, the camera looks upward toward a subject. This angle can make the subject look powerful.

MEDIUM SHOT (MS) The subject and background share equal dominance in the panel. A medium shot of a character will take in the body from the knees or waist up, with incidental background decided upon by the writer/artist.

MINI-SERIES Tells a story in a planned limited number of comics or graphic novels.

MONTAGE A combination of illustrated images used for flashbacks, accelerated pacing of a story, transition between scenes, and emotional devices to engage the reader.

ONE-POINT PERSPECTIVE The concept that things look smaller the farther away they are from you. Objects such as roads, buildings, cars, and fences appear to reduce in size toward the horizon, converging on a single spot, or vanishing point.

PANEL An individual frame in the multiple-panel sequence of a comic book. It consists of a single drawing depicting a frozen moment.

PANEL TRANSITION The method a creator takes the reader through, using a series of static images. It clearly transitions the action of one panel to the next.

PARALLEL LINES In perspective drawing, two or more lines at equal distance from one another are dictated by horizontal and vertical directions that do not converge to a vanishing point. The only time diagonal lines ever converge is found in isometric perspective, where all lines are infinitely parallel because no vanishing point or horizon line exists.

PENCILER An artist who works in the creation of comic books and graphic novels. The penciler is the first step in rendering the story in visual form and may require several steps of feedback from the writer. These artists are concerned with layout (positions and vantages on scenes) to showcase steps in the plot.

PERPENDICULAR LINES Lines that are at right angles (90 degrees) to one another.

PICTURE PLANE The area perpendicular to the person's line of sight; it's like looking through an imaginary window pane of glass at the scene you are drawing.

PLOT A literary term for the events a story comprises, particularly as they relate to one another in a pattern, a sequence, through cause and effect, or by coincidence.

POINT OF VIEW (POV) A camera angle that allows the reader to view the action in the same way that a character within the panel can view it.

ROUGHS Conceptual sketches or thumbnails of layouts that help plan the story visually.

RULE OF THIRDS A technique designed to help artists build drama and interest in their work, whereby the artwork is divided into nine squares of equal size, with two horizontal lines intersecting two vertical lines. Elements of the composition should take care to not cross the lines, and points of interest in the work should land near where two lines intersect.

SCENE The setting in a narrative sequence with several panels that can run for a page or more involving key characters.

SCRIPT A document describing the narrative and dialog of a comic book. In comics, a script may be preceded by a plot outline, and is almost always followed by page sketches.

SETTING The time and location in which a story takes place. It initiates the main backdrop and mood for a story.

SOUND EFFECTS (SFX) A lettering style designed to visually duplicate the sound of a character or action.

SPEED LINES Often in action sequences, the background will have an overlay of neatly ruled lines to portray the direction of movement. Speed lines can also be applied to characters as a way of emphasizing the motion of their bodies.

SPLASH PAGE A full-page drawing in a comic book, often used as the first page of a story. It includes the title and credits, and is sometimes referred to simply as a "splash."

SPOTTING BLACKS The process of deciding what areas in a comic panel should be solid black. This gives the illustration depth, mass, contrast, and a focal point on the character or action of the panel.

STATION POINT The point of view from which a person is standing or sitting as they look upon the subject in relation to the picture plane within the cone of vision.

STORY ARC An extended or continuing storyline in episodic storytelling media such as television, comic books, comic strips, board games, video games, and, in some cases, films.

TANGENT When two objects within a panel (or in separate panels in close proximity) confuse the eye and create unusual forms, thereby disrupting the visual narrative. Often, it's the panel border, or a similar linear composition in a nearby panel, that creates unwanted tangents.

THOUGHT BALLOON A large, cloud-like bubble containing the text of a thought.

THREE-POINT PERSPECTIVE A linear perspective in which, in addition to the two typical vanishing points, we find a third—either directly overhead or directly below our vantage point.

TIER A row of panels that run left to right horizontally. Traditionally, comic page layouts were designed with three tiers of panels.

TILT A cinematic tactic used to portray psychological uneasiness in the subject or compounding action within a panel.

TWO-POINT PERSPECTIVE As in one-point perspective, this is the concept where things appear smaller the farther they are away from you—but as two sides of the subject are visible, the parallel lines of each one converge to a different vanishing point.

VANISHING POINT (VP) The point on the horizon line at which parallel lines of an object seem to converge. There may be only a single VP, or there may be multiple ones. These points are not fixed, but are determined by what you are seeing and where you are seeing it from (your viewpoint).

WORD BALLOON An oval shape used to communicate dialog or speech.

WORM'S-EYE VIEW A low-angle shot from the ground, looking up at the focus of the composition. It is used to make the subject more imposing and larger than it appears to be.

ZOOM A shot that moves toward or away from the central character or focal point in a panel.

INDEX

CREDITS

Pp 2: Amrit. **Pp 9:** Jeff Himes, chimpchampdesign.com, *The Atomic Yeti* is copyright © 2012 by Daniel Cooney. All Rights Reserved. **Pp 12:** Pete McDonnell, mcdonnellillustration.com. **Pp 16:** *Xenozoic* is trademark and copyright © 2018 Mark Schultz. **Pp 21:** Art by Adam Wallenta, Gabriel Mayorga, and Lea Jean Badelles, www.punktaco.com. **Pp 23:** Jeff Himes, chimpchampdesign.com, *The Atomic Yeti* is copyright © 2012 by Daniel Cooney. All Rights Reserved. **Pp 27:** *Usagi Yojimbo Book 5: Lone Goat and the Kid,* Copyright © Stan Sakai. Courtesy of Fantagraphics Books, www.fantagraphics.com. **Pp 28: tr** *Castle Waiting,* Copyright © Linda Medley. Courtesy of Fantagraphics Books, www.fantagraphics.com, **cl & cr** Donatas1205/ © Shutterstock. **Pp 42: tr** Amrit, **l** Leonard Starr's *Mary Perkins On Stage,* Courtesy of Class Comics Press, www.classiccomicspress.com. **Pp 44: t** Judge Dredd ® is a Registered Trademark. Judge Dredd Copyright © Rebellion 2000 AD Ltd, All Rights Reserved. Used with permission, **bl** *Last Act of a Living Legend,* Copyright © Bill Pearson and Steve Stiles. Courtesy of Fantagraphics Books, www.fantagraphics.com. **Pp63:** Springball ® is TM and © Shanth S. Enjeti, www.enjeticomics.com. **Pp 64: cl & br** Ociacia/© Shutterstock. **Pp 66: t** Rafie van Geam / © Shutterstock, **b** Vincent Noel/© Shutterstock. **Pp 72: tr** *Castle Waiting,* Copyright © Linda Medley. Courtesy of Fantagraphics Books, www.fantagraphics.com. **Pp 74:** Robot illustration by Glenn Urieta. **Pp 78: t** Jerry Horbert/© Shutterstock. **Pp 82: t** DrMadra/© Shutterstock. **Pp 84: c** Art by Adam Wallenta, Gabriel Mayorga, and Lea Jean Badelles, www.punktaco.com. **Pp 86: br** Copyright © Linda Medley. Courtesy of Fantagraphics Books. **Pp 88: bl** Art by Adam Wallenta, Gabriel Mayorga, and Lea Jean Badelles, www.punktaco.com, **br** *Usagi Yojimbo Book 5: Lone Goat and the Kid,* Copyright © Stan Sakai. Courtesy of Fantagraphics Books, www.fantagraphics.com. **Pp 105:** *Castle Waiting,* Copyright © Linda Medley. Courtesy of Fantagraphics Books, www.fantagraphics.com. **Pp 106:** Artwork by George Huszar, www.georgehuszar.com. **Pp 108:** *The Tommy Gun Dolls,* © 2010 Dan Cooney. All Rights Reserved. **Pp 122: l** Dan Cooney, *Catwoman* © DC Comics. All Rights Reserved. **Pp 124: tr** *Castle Waiting,* Copyright © Linda Medley. Courtesy of Fantagraphics Books, www.fantagraphics.com, **br** Jeff Himes, chimpchampdesign.com, *The Atomic Yeti* is copyright © 2012 by Daniel Cooney. All Rights Reserved. **Pp 126: tr** Jeff Himes, chimpchampdesign.com, *The Atomic Yeti* is copyright © 2012 by Daniel Cooney. All Rights Reserved, **bl** *Castle Waiting,* Copyright © Linda Medley. Courtesy of Fantagraphics Books, www.fantagraphics.com. **Pp 129:** Vacclav/© Shutterstock. **Pp 130: t & bl** Jeff Himes, chimpchampdesign.com, *The Atomic Yeti* is copyright © 2012 by Daniel Cooney. All Rights Reserved. **Pp 145:** Jeff Himes, chimpchampdesign.com, *The Atomic Yeti* is copyright © 2012 by Daniel Cooney. All Rights Reserved. **Pp 146:** Penciled by Chris Marrinan, inked by Andrew Pepoy, *Batman* copyright © 2012 DC Comics. All Rights Reserved. **Pp 150 & 151:** Jeff Himes, chimpchampdesign.com, *The Atomic Yeti* is copyright © 2012 by Daniel Cooney. All Rights Reserved.

AUTHOR'S ACKNOWLEDGMENTS

I would like to give my most sincere thanks to the artists whose work appears throughout this book—I'm so grateful to be surrounded by such amazing talent. Your visual narrative work, draftsmanship, and friendship have provided continuous inspiration. In turn, I hope aspiring artists find this book inspiring as well. Many thanks to the talented folks at Quarto Publishing for their patience and enthusiasm from the early concept to completion. This book is dedicated to my sons, Dashiell and Dexter, for their love, support, and humor—those qualities are building blocks for a lifetime of learning.